IMAGES
*of America*

# LANCASTER

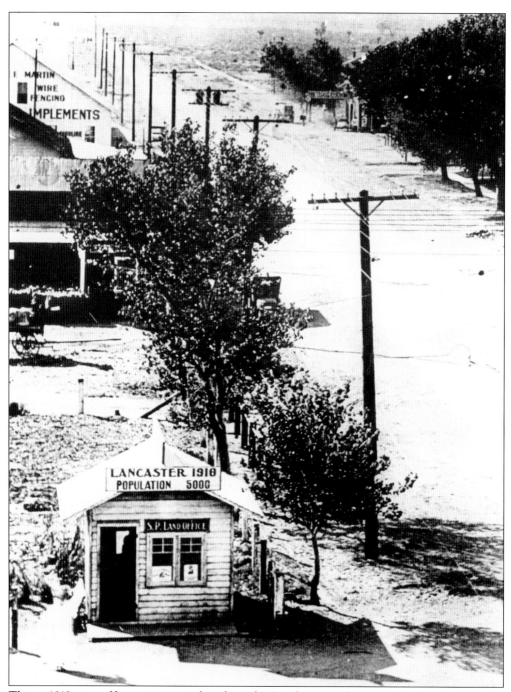

This *c.* 1918 view of Lancaster was taken from the Southern Pacific Railroad water tower at the northeast corner of Antelope Avenue (Sierra Highway) and Tenth Street (Lancaster Boulevard). The sign at the S.P. Land Office is not correct; Lancaster did not have 5,000 residents at this time. The town's population was about 1,550.

# IMAGES
# *of America*

# LANCASTER

Norma H. Gurba

ARCADIA

Published by Arcadia Publishing
Charleston SC, Chicago IL, Portsmouth NH, San Francisco CA

Printed in the United States of America

Library of Congress Catalog Card Number: 2005920108

For all general information contact Arcadia Publishing at:
Telephone 843-853-2070
Fax 843-853-0044
E-mail sales@arcadiapublishing.com
For customer service and orders:
Toll-Free 1-888-313-2665

Visit us on the Internet at www.arcadiapublishing.com

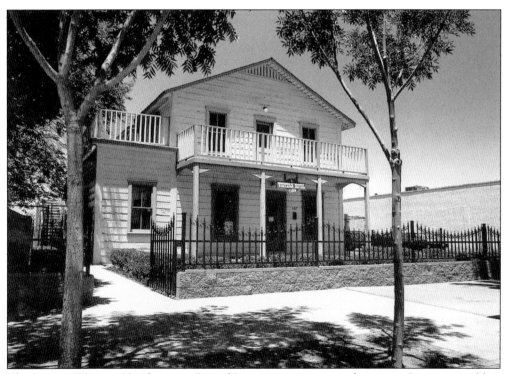

The historic Western Hotel, now a City of Lancaster museum, is downtown Lancaster's oldest
structure, dating from around 1888.

# CONTENTS

# ACKNOWLEDGMENTS

It has been an enriching experience writing this book, which is the result of efforts on the part of numerous people who are dedicated to the preservation of Lancaster's special history and keeping it vividly alive.

I wish to thank the following people and organizations that have so generously donated photographs, glass plates, and negatives for two decades to the City of Lancaster Museum/Art Gallery. Their donated source materials are the essence of this book; contributions were made by Joy Beck, Louis and Annie Brandt, Edwards Air Force Base–Air Force Flight Test Center, Harry and Katherine Granger, the Halden family, Kern Antelope Historical Society, Steve Kucharik, Lancaster Library–Los Angeles County, Frank and Vonnie Lane, Len Leydecker, Adelle Beery Maricich, Mildred and Eldon McLaurin, Harold Mitchell, Kay Philips, Grace and Arthur Pickus, Walt Primmer, the Maurice "Jumbo" Reynolds family, Phyllis and Perry Row, Lois Scates Selby, the George Stoore family, Lily T. Stradal, Fred Strasburg, Irene Swenson, Dave Walden, Dale Wallis, Western Hotel Historical Society, and Josephine Williams. Special acknowledgment goes to Glen Settle and his late wife, Dorene Burton Settle, who donated so many photographs from the archives of their Tropico Gold Mine Museum, and the West Antelope Valley Historical Society, which was instrumental in providing imagery.

This book would not have been possible without the individuals who have given valuable hours and assistance in its preparation, including Carol Cole (City of Lancaster–Department of Parks, Recreation, and Art), Milt Stark and Walt Primmer of the West Antelope Valley Historical Society, and Frank Stubbings of Stubbings Studio.

I am also grateful to the entire City of Lancaster Museum/Art Gallery staff who helped in so many different ways: Nancy Mossman, Jessica Parker, Jennifer Miranda, Tori Notz, Jonathan Baker, and especially David Earle.

And lastly, sincere appreciation is conveyed to my dear husband, Ron Kleit, who, as always, was so encouraging and so patient during the months of the book's preparation.

Proceeds of book sales will go to the LMAG Associates, the City of Lancaster Museum/Art Gallery's support/fundraising organization.

# INTRODUCTION

The City of Lancaster, which measures 94 square miles in area, is wedged into the northernmost portion of Los Angeles County. Incorporated in 1977, this high desert inland city of nearly 128,000 is located in the Antelope Valley, which is situated in the westernmost part of the Great Mojave Desert. The Antelope Valley is bordered by the Tehachapi Mountains in the north and the San Gabriel Mountains on the south. Lancaster, located approximately 70 miles northeast of Los Angeles, has been the regional and community center of the valley since the early 1880s.

Historically, it has not been that long since the first white person set foot in this region. The earliest inhabitants were the Takic- and Numic-speaking Native Americans, and traces of their settlements have been located within the city's limits.

The earliest explorers who ventured into the Antelope Valley on various expeditions from 1772 to 1806 were Hispanic. The first recorded entry of a European into the region was made in 1772 by Capt. Pedro Fages. The valley was later explored by several famous expeditions in the 1840s and early 1850s. In 1853, the U.S. War Department railway survey expedition led by Lt. Robert S. Williamson surveyed and described the valley. The members of this survey party may have been the first documented non-native people to travel across what was to become Lancaster.

On August 8, 1876, workers laying tracks on the Southern Pacific Railroad route from Bakersfield toward Los Angeles reached the site of modern Mojave. About 3,000 workers (including 1,500 Chinese) passed through the area that would become Lancaster. Soon after, the Southern Pacific built a roundhouse for engine repairs and shacks for railway maintenance workers, although nothing else was built there for several years.

Like many other towns in inland California, Lancaster was literally created by the railroad, and no settlement existed there before the coming of the steel tracks. Why was this site—the intersection of present-day Sierra Highway (old Antelope Avenue) and Lancaster Boulevard (old Tenth Street, which should not be confused with present-day Tenth Street West)—selected for the site of a railroad siding? Availability of subsurface water may have been a factor. Early facilities of the Southern Pacific Railroad (SPRR) included a water well, a 1,400-foot siding, three section houses for employees, a garage for a hand-car, and a tool house. It was not until 1884 that Lancaster became a full station depot with a railroad/passenger agent.

But where does the name Lancaster come from? Reports differ as to how the town acquired its name . . . .

7

Some pioneers said that Lancaster was named by the town's founder, Moses Langley Wicks, a prominent real estate developer in Southern California. Wicks purchased 60 sections of land from the SPRR in 1884 and then had the town of Lancaster surveyed and recorded on February 16, 1884. He supposedly named the town after his birthplace of Lancaster, Pennsylvania; however, records show that he was born in Aberdeen, Mississippi.

Other reports say that settlers may have named the town in 1876 after their former home in Pennsylvania. But there were no "settlers" in what was to become Lancaster in 1876, only railroad employees. However, a SPRR map dated to the end of 1876 does identify a Lancaster siding track, although not a town.

According to a SPRR directory, a clerk named J.W. Lancaster was working at this station around 1883. It is not known if Mr. Lancaster was working there in 1876 but it is interesting to note that in the early days an employee named Lancaster worked at the Lancaster station. Any SPRR records that could have revealed why the name Lancaster was given to this community were unfortunately destroyed during the 1906 San Francisco earthquake. Local historians today are still not exactly sure why the name was selected.

The earliest residents in Lancaster were male railroad employees. Around 1882, a woman named Anna Sorenson claimed that she was the only female living within the town's limits. In 1883, the first artesian well in the valley was sunk for locomotive use near the SPRR tracks. Soon after this, attractive promotional literature designed to draw settlers to the developing town of Lancaster appeared. The first commercial structure was a lumberyard built by Moses Wicks. Newcomers came by wagon, stagecoach, train, and foot to Lancaster. By 1886, the *Los Angeles Daily Times* reported: "Lancaster is the business center of the Antelope Valley . . . there is a telegraph station, post office, newspaper, express office, several stores, a hotel, and livery stable. The land ranges from $2.50 to $20 an acre. Land seekers are arriving daily by train." Lancaster was experiencing quite a boom—for a while.

Wet years and abundant rain attracted many settlers, who turned to dry farming, a hard and risky business. From 1895 to 1905 Southern California was hit by devastating drought, and homesteads were abandoned as many people moved away. It took several years for the population to grow again. Good times returned with the construction of the Los Angeles Aqueduct, as local men joined the labor crews and Lancaster merchants provided supplies and food items to the workforce.

After 1905, agriculture began to revive in the valley. Irrigation and electricity for pumping permitted the development of the alfalfa industry. Alfalfa would soon be "king" as it began to dominate the valley's economy around 1930.

By 1941, the Lancaster Chamber of Commerce reported: "Lancaster is the main shopping center of the valley, a thriving and progressive community of modern stores and homes, churches, high school, grade schools and hospitals and with a spirit of community activity which keeps in touch with the needs and demands of the people of the entire valley."

And change it did, from a sleepy little agricultural community to one of the largest cities in Los Angeles County. The needs and demands of the area began to change as the jet age was ushered in at Muroc Army Air Forces Base when Bob Stanley took off in a Bell XP-59A in October 1942. Five years later Capt. Chuck Yeager flew the Bell X-1 faster than the speed of sound. Several early test pilots resided in Lancaster, including Neil Armstrong, the first man to walk on the moon. During the late 1950s and early 1960s, more and more people moved to Lancaster to work at Edwards Air Force Base, the birthplace of *The Right Stuff* with its aviation milestones.

This book will hopefully give longtime residents a nostalgic feeling as well as help new Lancaster residents to understand how this small town has emerged as today's modern city, a city that is constantly changing and progressing with new milestones waiting to be established.

# *One*

# BIRTH OF A COMMUNITY

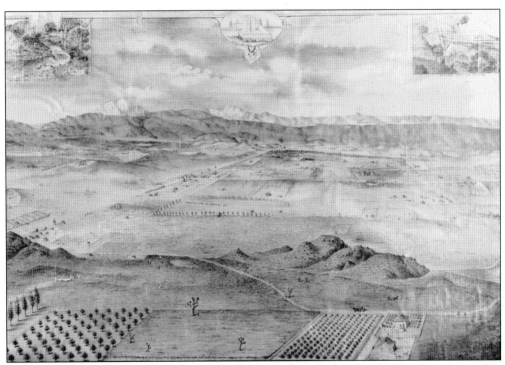

This lithograph of the Antelope Valley (AV) appeared in the *Los Angeles Herald* in September 1887. The scene is depicted from a hilltop in the Rosamond area looking south and shows an area of approximately 25 by 40 miles, with the little town of Lancaster in the center. Copies of this AV-Lancaster map were most likely used as a real estate promotional item. In the mid-1880s Lancaster had about 100 residents.

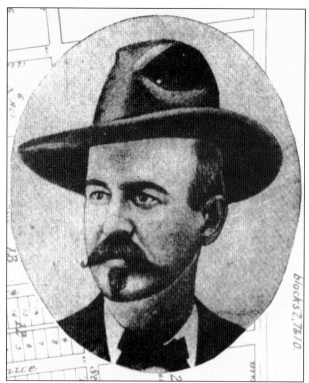

Moses Langley Wicks was a prominent real estate developer who arrived in the early 1880s to start a colony on the valley's west side. After purchasing 60 sections of land at $2.50 an acre from the Southern Pacific Railroad in 1884, Wicks then had the town of Lancaster surveyed by B.A. Bernal, laid out with streets and lots, and recorded on February 16, 1884, at 2:45 p.m. He also built Lancaster's first commercial structure, a lumberyard.

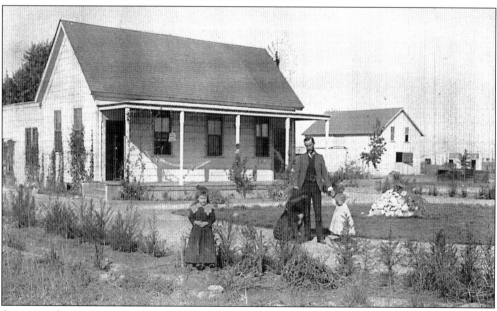

Sometime between 1886 and 1888, Wicks gradually sold his land to James P. Ward for $46,620. Ward homesteaded 160 acres from Avenue G to Lancaster Boulevard to Tenth Street West. Confident of the agricultural future of the region, he heavily advertised the town, in which he owned the livery stable, a thriving lumberyard, and the blacksmith shop. In fact, at one time Ward owned every other section of land in Lancaster. He is shown here with his children at his Lancaster house.

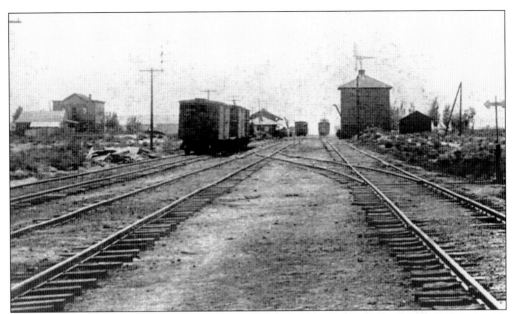

This photograph is probably the oldest view of Lancaster, *c.* 1890. On the far left looking south is the Lancaster Hotel, which was later destroyed by fire, and the train depot. On the right is the large water tower and windmill. In 1885, Lancaster had a "tent" Chinatown, a blacksmith, and two flowing artesian wells, one of which furnished water for the railroad tank. Lancaster was experiencing a "boom."

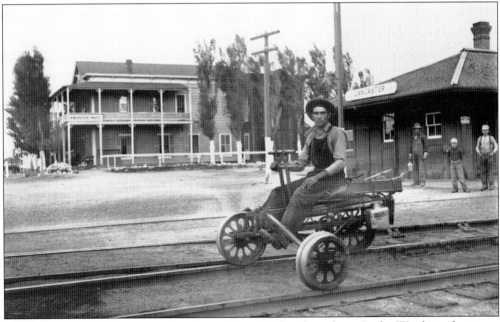

The railroad was old Lancaster's main employer. Railroad employee Leslie Wright is shown on a three-wheeled, hand-powered handcar in front of the train depot *c.* 1902. The first depot was an early tent or "shack" depot. A small passenger depot was completed by July 1885 and the station was later enlarged. The train trip to Los Angeles during the late 1880s took four-and-a-half hours and cost $7.50 roundtrip.

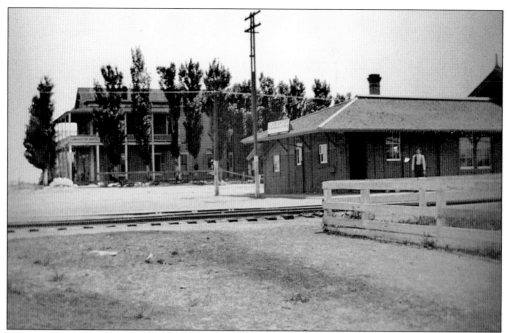

The train station included a section house, several small workers' houses, a loading dock, a garage for the handcar, and a waiting room with wooden benches and a potbelly stove. Through the years, additions and changes were made to the depot. Passenger train service in the AV continued until 1971. A fire, which was started during a burglary, destroyed the Lancaster station in July 1976.

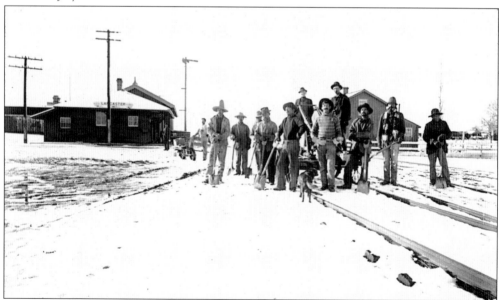

Every 20 miles of track was maintained and repaired by a different section gang. The Lancaster section gang, *c.* 1902, was composed of Mexican, Italian, and American workers. Jim Foster, the section foreman, is at the rear left. Possibly the first organized strike in the AV took place in October 1902 with Mexican railroad section workers in Acton striking for $1.60 per day, the amount paid to Anglo workers.

# *Two*

# PLANTS AND ANIMALS

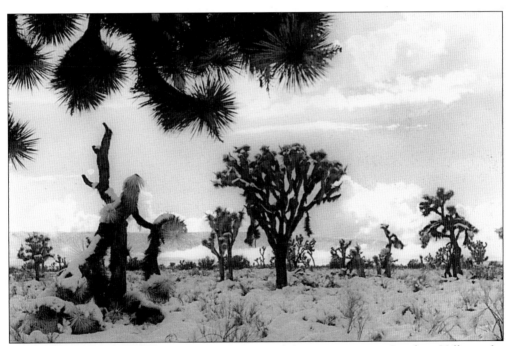

One of the most identifiable plants in Lancaster and the entire western Antelope Valley is the Joshua tree (*Yucca brevifolia*), which is found only within the Mojave Desert. In 1857, a group of Mormons passing through the Mojave Desert on their way to Salt Lake City believed these strange-looking trees appeared to be pointing and guiding them to their destination. They named them "Joshua" after the man who led the Israelites into the Promised Land.

This plant is often mistakenly called a cactus or a palm. Technically, the long, narrow leaves, six-petal flowers, and rhizomes place it in the lily family. Joshua trees may live to be several hundred years old and some subspecies may grow to be over 40 feet tall, as is this one, which was located at Avenue K and Sixtieth Street West. Linda Kucharik poses by the tree in 1960, which unfortunately had to be removed as it was believed that falling limbs could be a potential hazard.

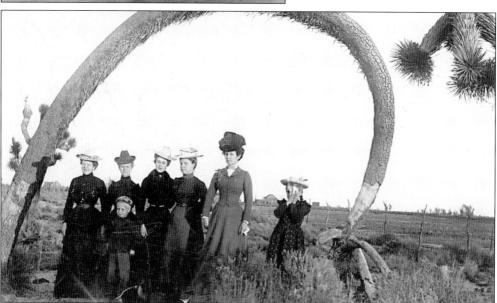

This curved and twisted Joshua tree, shown with members of the Doyle family and friends, was a popular photographic spot. John C. Fremont, who trekked here with guides, hunters, and an artist in the spring of 1844, named the Mojave River and gave the first detailed and vivid description of the fauna, flora, and geology of this valley. He described the Joshua tree as "yucca," the most repulsive plant in the vegetable kingdom.

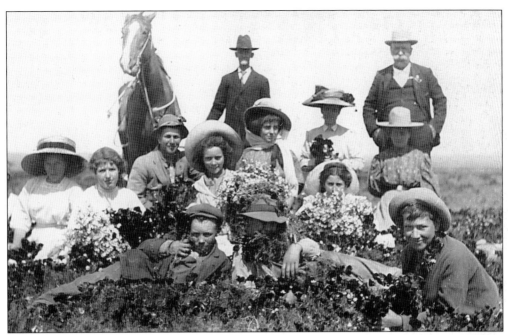

Another plant synonymous with the Lancaster area is the beautiful state flower, the golden California poppy (*Eschscholtzia calfornica*). The region is known worldwide for its spectacular annual springtime displays of colorful poppy fields. In this 1903 photo, Susie and Aaron Oldham, Mrs. Olcott Bulkley, son Olcott, and Reverend Amos, among others, enjoy the poppy fields. A black and white photograph does not do justice to these poppies!

Today, pioneer Lancaster Grammar School principal A.H. Riddell would have to pay a stiff fine for picking state-protected poppies. Most poppies in the region range from 6 to 18 inches tall; they usually have four petals, but some may have six to eight.

Artist and conservationist Jane Pinheiro (left) is shown with Warren Dorn (second from left), Los Angeles County's Fifth District supervisor, serving from 1956 to 1974. Pinheiro, known as the "Great Poppy Lady," created wildflower paintings noted for their botanical accuracy. She also worked tirelessly with Dorothy Bolt and dedicated members of the Lancaster Woman's Club to establish the AV California Poppy Reserve in the west side of the valley.

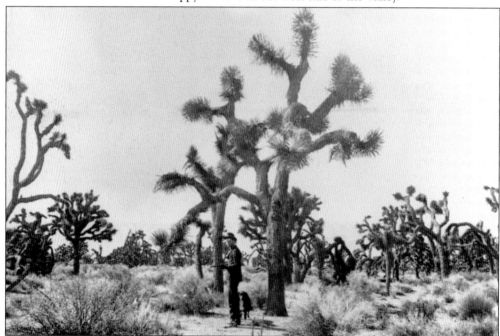

Hunter John Graham and his dog get ready to shoot in a Joshua tree forest near old Palmdale on March 12, 1902. Hunting was a favorite pastime and, of course, a way to avoid starvation in bad times. Brave Lancaster hunters armed with rifles would go in search of bears, mountain lions, and bobcats.

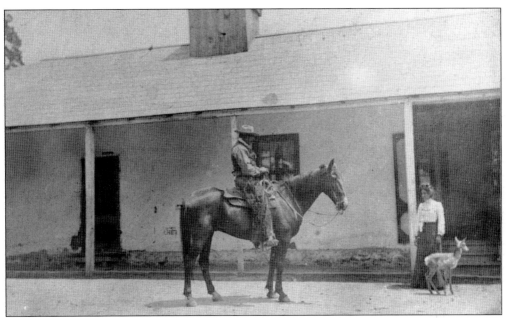

Lancaster is located in the Antelope Valley, and there are many reports from early reputable travelers, settlers, and hunters recording sightings of antelope pronghorn. Antelope meat was also sold to local hotels. While there is some early physical evidence of their existence, their exact number is not known and it is unclear why they disappeared. This photograph shows Antonio Araujo and his daughter Sally at La Liebre Ranch in 1903 with a "tame" antelope fawn.

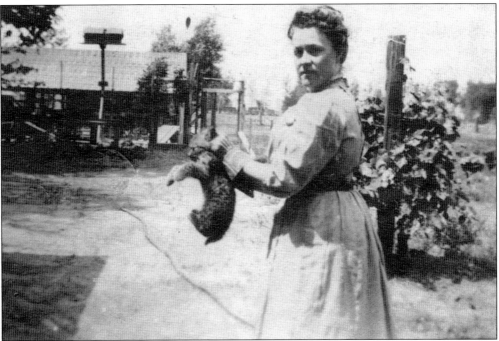

In 1909, Mrs. Harry Vreeland had a most unusual pet—a young wildcat. Solitary and territorial, bobcats, like coyotes, would roam the area and cause havoc by attacking chickens. Although fewer in number today, bobcats can still be found in the region.

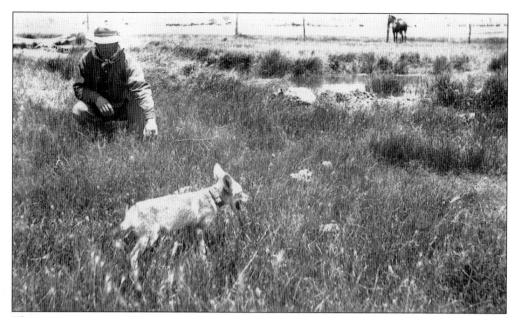

This coyote was caught in a trap in 1902. Coyotes raided chicken coops and caused many problems. In 1892, the Lancaster Antelope Valley Bank added buying coyote scalps to its services. "We will advance money on coyote scalps; bring your scalps to the Bank and we will do the rest." Local stores also took coyote pelts and farm produce, especially eggs, from their customers in return for store merchandise.

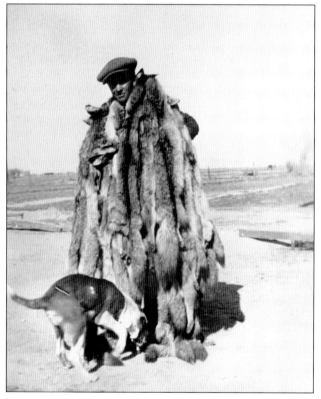

Coyotes were plentiful around Lancaster. Trapper Harold True is shown here with many coyote pelts, which his dog does not like. Savvy survivors, coyotes can still be seen today running about in Lancaster.

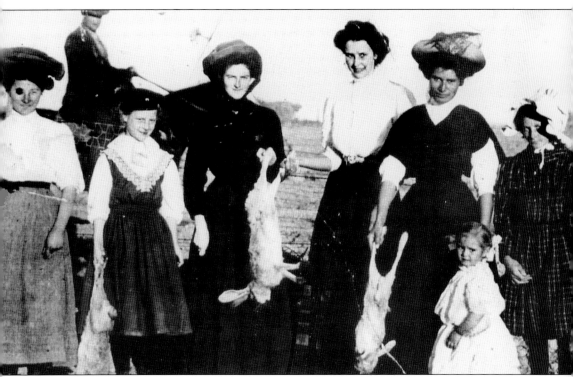

The desert cottontail rabbit and the black-tailed jackrabbit are perhaps the most frequently seen native mammals in the Antelope Valley. Coyotes, bobcats, and hawks are their enemies. Jackrabbits caused many problems for early Antelope Valley farmers from the 1880s to the 1920s, partly because the farmers killed many coyotes, their natural enemies. The rabbits also gnawed at the trees, ate the crops, and multiplied quickly. One pioneer, Evan Evans, said that at night it looked like the ground was moving because there were so many rabbits. To eradicate them, rabbit drives were held, and special Sunday trains often came in from Los Angeles with participants. Out on the desert floor, men on horseback or on foot would form a large circle and gradually close in on the rabbits, driving them into improvised corrals where they were beaten to death with clubs. Men, women, and children would participate in these rabbit drives. These ladies and young girls were involved in a rabbit hunt c. 1902.

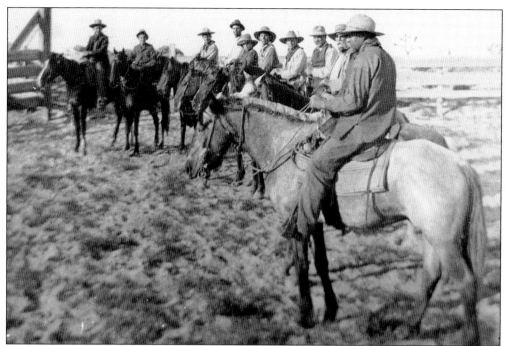

It is hard to imagine in modern-day Lancaster that wild horses, not fast cars, once raced across the land. Wild horses and cows were seen in the valley in the early 1860s. In 1884, a Los Angeles paper reported an area about six miles southeast of Lancaster where wild horses were seen almost every day. Although these turn-of-the-century cowboys were on trained horses, according to some reports there were a few wild horses here until the 1940s.

For many years, big turkey operations could be found throughout the valley. By 1930, the local turkey population was estimated at 40,000, while in 1940 the valley produced about 150,000 turkeys annually. However, due to economic problems caused by the recession of the early 1980s, many turkey ranchers stopped raising them. Today, Lancaster has some local chicken ranches but no turkey ranches and thus no local turkeys for Thanksgiving dinners.

# *Three*

# A Good Place to Live

Few things define a town's history and character more than its buildings. Pioneer houses in Lancaster usually reflected a hard-working, simple life and included mud-adobes, clapboard "shacks" that provided little relief from desert weather extremes, simple one-story "ranch" houses, and a few two-story residences. Here is one of the two-story houses in its later years.

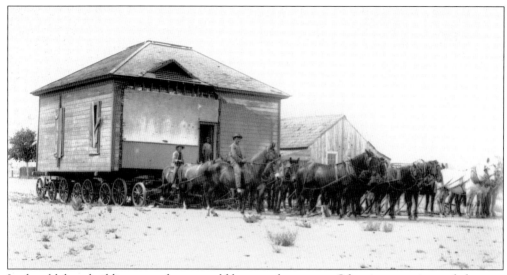

In the old days, building a new house could be a costly venture. Often it was easier, and cheaper, to move an established house from one location to another. Here, a house in Fairmont is moved about 20 yards with the help of 28 horses. David Menzies, Fred Gierer, and Tom Reynolds are seen in this view.

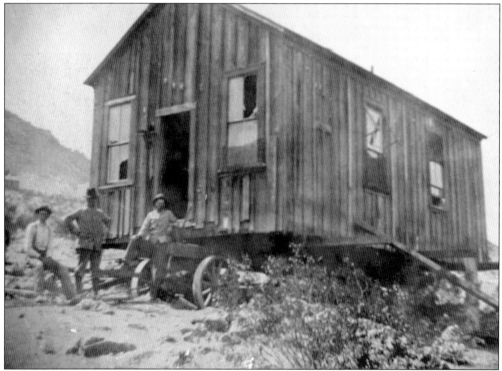

Susie Wright Oldham's house in the Big Rock Creek area was taken apart and moved to Lancaster in the early 1890s. When Judge Olcott Bulkley moved from Palmdale to Lancaster in 1902, he bought an old Palmdale house and had it transported on four wagons and 20 horses to a lot on Beech Avenue in Lancaster. Here, an early house on Soledad Mountain is being transported to Mojave.

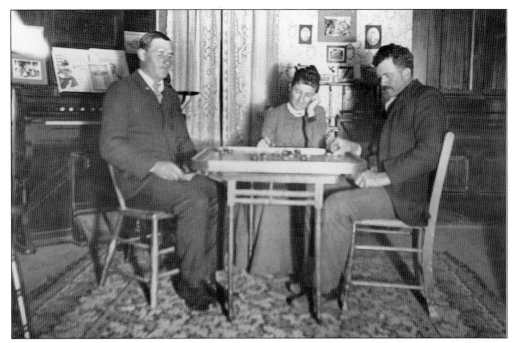

Not many interior views of Lancaster houses exist. Here, the Menzies family plays a challenging game of checkers on March 1, 1902. Although plain and simple on the outside, the house's interior shows nice Victorian details.

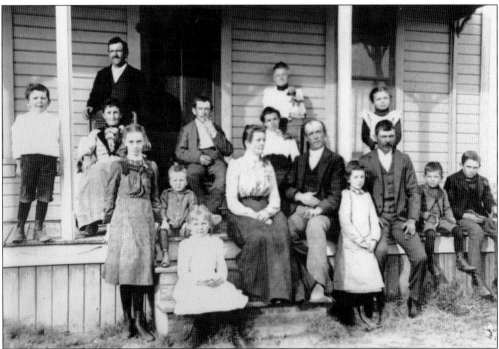

A gathering of the Menzies family celebrates a special occasion on the house's roomy front porch. Some members of the Menzies family lived in the west end of the valley, while others lived in the Lancaster area.

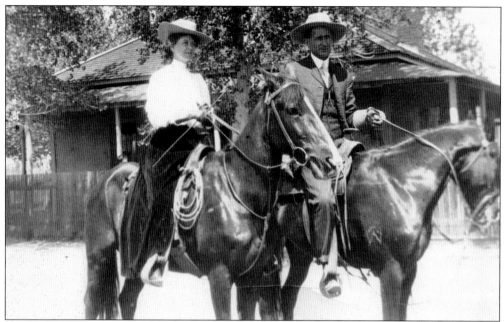

Mrs. and Mrs. E.E. Cummings take a leisurely ride past Harry Vreeland's Lancaster home in 1907. Many of the photographs in this book came from Cummings's original collection, which he gave to the Antelope Valley Old Timers Association and, which in turn, has been donated to the West Antelope Valley Historical Society.

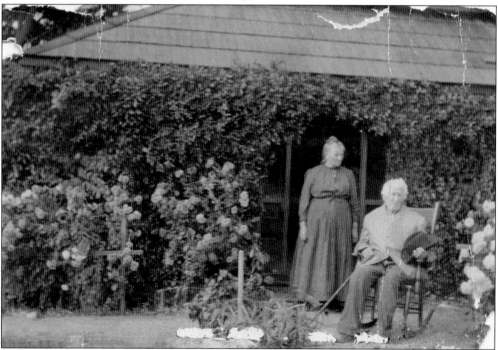

Pioneers Mr. and Mrs. Sam Storey are shown at their rose-covered home on Cedar Avenue in 1906. Well known locally for its beautiful roses, the house was later moved to the former Tropico Gold Mine Museum.

Today, it is hard for many people to imagine living in pioneer houses that lacked so many modern amenities such as electricity, indoor bathrooms, running water or gas like this early Lancaster house around 1902.

The Halden homestead during the 1940s was located about 12 miles north of Lancaster. It was not very spacious but it was home.

When does a settlement actually become a town? Even though a town may be depicted on paper it does not officially come to life until its citizens' basic needs are met through a post office, general stores, blacksmiths, churches, saloons, a sheriff's office, and, of course, schools. This is Miss Ford, a teacher at the second Lancaster Grammar School.

The Lancaster School District was formed on August 3, 1885. When the first public Lancaster Grammar School opened that fall, it was in a modest house near the northwest corner of Antelope Avenue and Eleventh Street (Milling Avenue) that had been converted for school use. The district had 14 pupils and the first teacher was Miss Maria A. Parmalee (Stewart). These are the school personnel photos for another teacher, Miss May Egan, who taught here from 1889 to 1890.

As the little town of Lancaster continued to grow so did the school population, and soon a new building was needed. An impressive two-story red brick structure with a bell tower was constructed on the south side of Tenth Street between Beech and Cedar Avenues, across the street from the Gillwyn Hotel. The second Lancaster Grammar School was first occupied in early 1890. This scene shows a snowy Lancaster School on February 3, 1903.

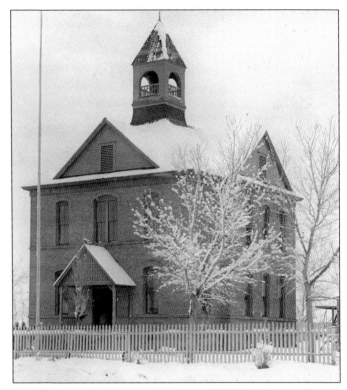

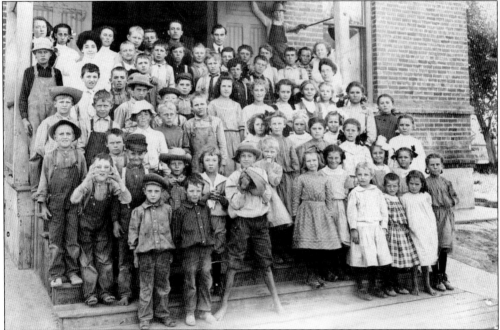

Built at cost of $3,950 by local builder and brick-maker O.B. Allen, the school became the hub of the community with Sunday church services, dances, Christmas pageants, elections, political meetings, town hall meetings, plays, picnics, and assorted social gatherings. This 1910 view shows Miss Barr's, Miss Conkle's, and Principal H.R. Riddell's students.

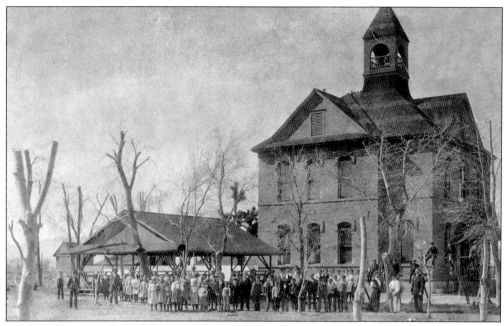

By 1911, there were four teachers and 100 pupils, and a new, larger school was planned for a site on Cedar Avenue. The old school was used for different purposes for several years, including a temporary high school from 1914 to 1915, as well as the chamber of commerce, a library, and a Masonic Hall. In 1933, a major earthquake, centered in Long Beach, heavily damaged the structure, and this piece of Lancaster's history was demolished in 1934.

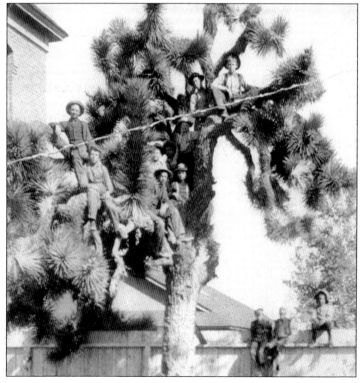

Recess provided escape from hard school benches. Ouch! These boys have displayed amazing skill in climbing this large Joshua tree without seriously injuring themselves on the sharp spines. The tree grew in the rear schoolyard of the second Lancaster Grammar School, which was located in the vicinity of the present-day Lancaster Chamber of Commerce office, across the street from the Western Hotel/Museum.

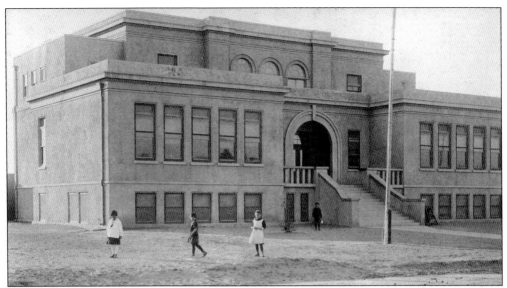

The third Lancaster Grammar School was completed in 1914; this photo is from the 1920s. The school was torn down in the 1950s, with the exception of the north wing and the auditorium, which is still used by the school district as a warehouse. On the top floor at this time was the auditorium where Mrs. Mollie Bloom Flagg organized the Lancaster Woman's Club in 1922; she also served as its first president. By 1929, there were 40 members.

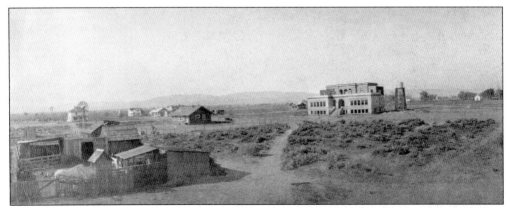

This is an overview showing the surrounding area around the third Lancaster Grammar School on Cedar Avenue. The photograph may have been taken from the second floor of Harry Keeler's house.

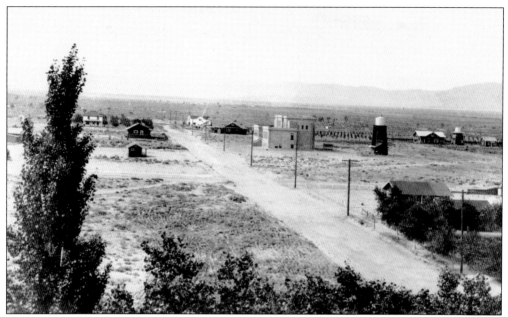

This view of the third Lancaster Grammar School looking south was probably taken atop the bell tower of the old second grammar school. The Mumaw's residence is at the far right; the family owned the only funeral parlor in the valley at the time.

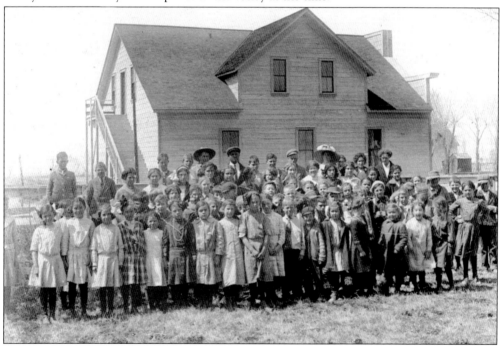

The wooden two-story Women's Independence Club Hall opened in 1907. This building had many uses: silent movie theater, dance hall, lecture room, skating rink, meeting hall, and temporary high school. It was originally located on the southwest corner of Tenth Street and Cedar Avenue, west of the old grammar school. The social center of the early days of Lancaster, it was moved to the west side of Beech Avenue in 1923.

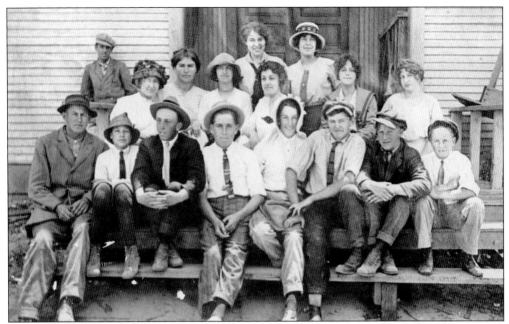

Although there was a ninth grade class in 1890 taught by Professor Holland at the second grammar school, the first officially recognized high school class was started in 1908 with a ninth grade class of five students. The AV Union High School was established in 1912. With attendance varying from 8 to 13 students, the new high school occupied the second floor of the Women's Independence Club Hall.

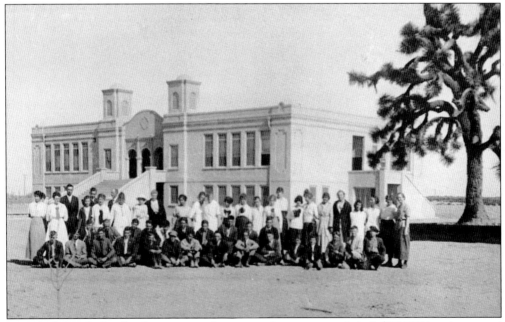

By 1914, larger high school quarters and more teachers were needed. A $60,000 bond was used for the creation of a new high school in 1915, and 20 acres of land in the area east of town were purchased from B.F. Carter. The first graduating class numbered four pupils. This is the 1916 student body. The high school annual, *The Yucca*, was named after the Joshua tree to the right.

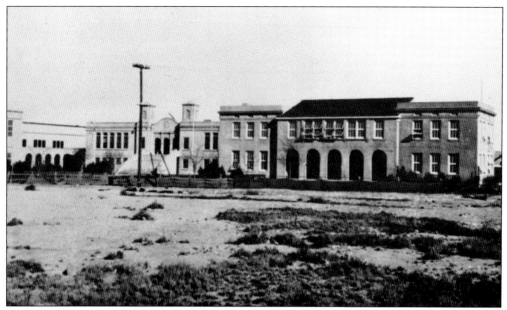

This is the AV High School several years later. Note the barrier across the entrance to keep the blowing sand from drifting across the lawn. When the school was originally planned, some people complained because it was located on the outskirts of town—at that time far from downtown Lancaster.

The school was first called AV Union High School, but in 1925 it became AV Joint Union High School. By 1930, there were more than 400 students and a faculty of 24 teachers in a district embracing parts of three counties. The AV Junior College was founded in 1929 as a department of the high school. The old high school was torn down in 1958. Today, thousands of students are enrolled in the AV Union High School District.

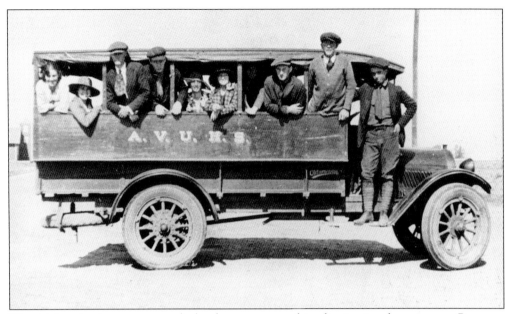

The high school once covered the largest geographic district in the country. Buses to transport high school students from rural areas came into use as roads and vehicles improved. Transportation of high school students began in 1919 with student drivers. Before then, pupils living beyond walking distance rode horses or drove in buggies to school. By 1925, there were seven buses in service and men were hired as drivers.

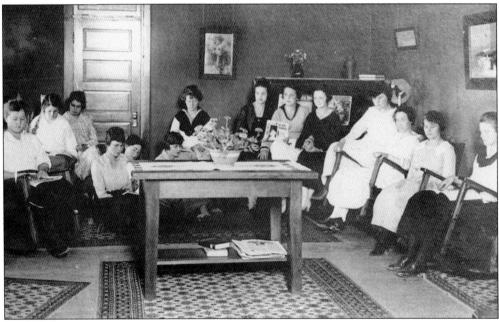

At one time, AV High School was the only high school between San Fernando and Bakersfield. It was the first school in California to adopt the dormitory system (1915), as many students lived far away. There was no charge for the rooms, and food costs were prorated. A matron (sometimes the home economic instructor) was in charge. The dormitories closed in 1933. This is an interior view of the girls' dormitory c. 1925.

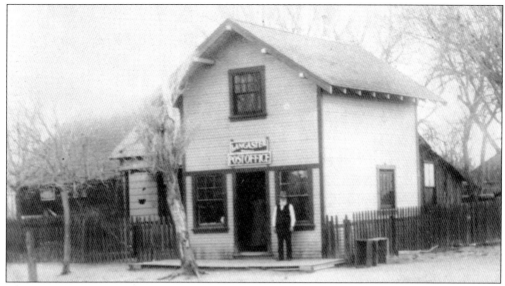

The second Lancaster Post Office was in a room in the home of J.F. Dunsmoor on the south side of Tenth Street just east of Beech Avenue c. 1912. Old-timers have reported that this was the center of life in Lancaster around 6 p.m. when the mail came in. The first post office, a small house, was situated on the northwest corner of Eleventh Street (Milling) and Antelope Avenue.

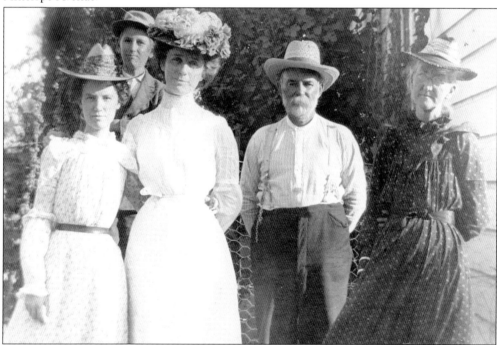

In 1884, William Baylis was appointed postmaster when a post office was established at Lancaster. One of the first federal jobs open to women was that of a postmistress. In 1889, Mrs. Ford was the postmistress. She lived next to the first grammar school; her husband was an architect and the preacher at the M.E. Church. J.F. Dunsmoor, postmaster from 1897 to 1913, is shown here with his family c. 1900.

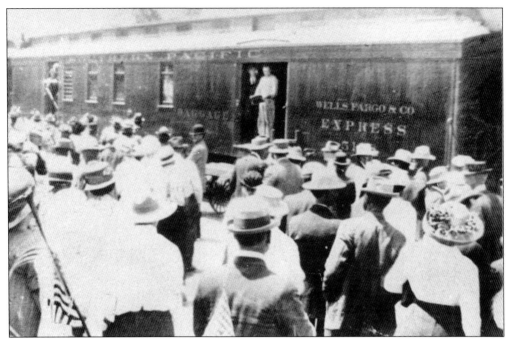

In November 1891, the local paper reported: "All passenger trains passing through Lancaster now take in and put off mail at this place. We now have four mails a day." Here, valley residents visit with friends and pick up packages and mail at the Wells Fargo Express car in Lancaster on a Sunday afternoon during the early 1900s.

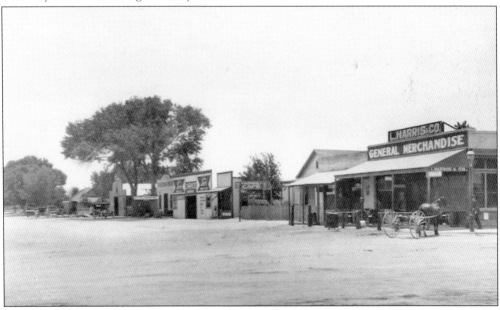

In 1914, the post office moved into the Leo Harris General Merchandise Store at the southwest corner of Antelope Avenue and Tenth Street. Harris, a popular merchant and civic leader, was one of the first prominent Jewish residents in Lancaster. Eventually this third post office was no longer adequate and it was time to move again. The Gottschalks-Harris Department Store in the AV Mall is part of the Harris family chain.

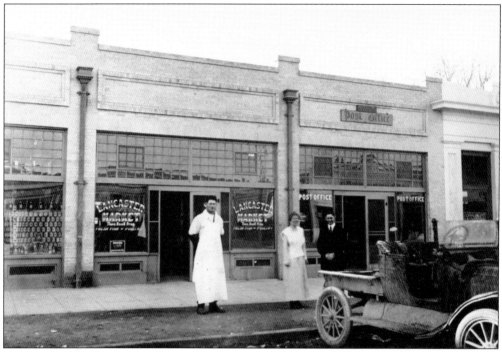

Butcher Ted Knoll stands in front of his Lancaster Market with then postal assistant William Redman. The post office was located next to the bank on the south side of Tenth Street, between Beech and Antelope Avenues—its fourth location in Lancaster. Redman was the postmaster from 1914 to 1922. This post office opened in February 1925.

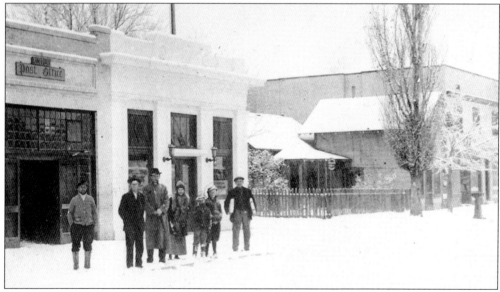

It is a snowy day for employees standing in front of the fourth Lancaster Post Office and the bank. Postmaster William Redman is the second person from the left. The adjacent two-story house to the right was the second post office and the home of former postmaster J.F. Dunsmoor. Next to this structure was a two-story brick office building and a hotel annex. The water fountain in front was a gift from the Lancaster Woman's Club.

The long brick building to the right served as the fifth post office in the 1930s. It was located east of the Western Hotel.

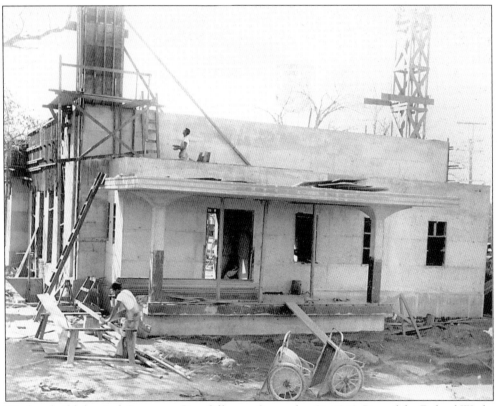

Workers build the sixth Lancaster Post Office on September 21, 1940. Part of the Federal Works Administration program, the post office was built for $75,000, and is still in use today at the northeastern corner of Cedar Avenue and Lancaster Boulevard. The seventh post office was built at Avenue J-2 and modern Tenth Street West. The newest post office—number eight—was recently built at Twentieth Street West and Avenue J-12.

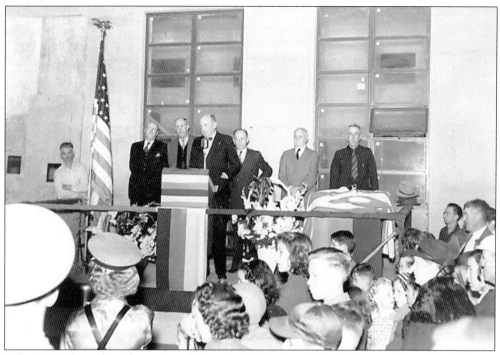

Judge McNeil stands at the podium during the dedication of the sixth post office at Tenth Street and Cedar Avenue. Postmaster L.C. Rowe is in the back row, second from the left.

Lancaster pioneer Susie Oldham Davis retrieves her first mail at the new downtown post office on Lancaster Boulevard. This was the sixth post office for growing Lancaster.

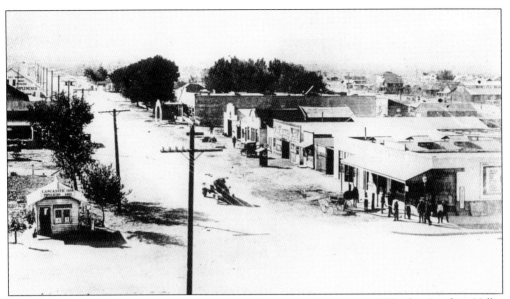

Not all early AV residents were enamored with Lancaster. In August 1889, the *Antelope Valley Times* wrote: "C.W. Dodenhoff (a Palmdale real estate and lumber dealer) paid Lancaster a visit last Saturday. He returned home very well pleased with his visit after visiting the Metropolis of Lancaster as he said he could never appreciate the rush and worry of life in the big city!" This view of Lancaster was taken from atop the railroad's water tower looking south on Antelope Avenue toward Palmdale.

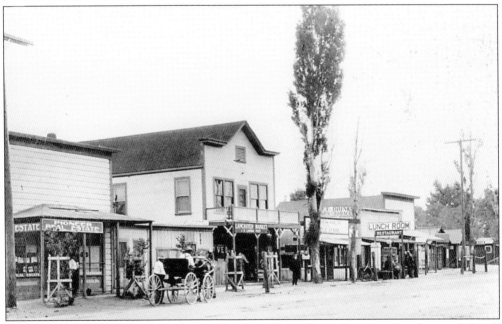

The main establishments along the north side of Tenth Street between Antelope and Beech Avenues in 1914 included, from left to right, Mom Evert's maternity home/doctor's office, the Pioneer Real Estate office, a private residence, the two-story Lancaster Market, restaurants, and other establishments. In 1913, a series of six ads describing Lancaster in glowing terms were run in *Sunset Magazine* with the $1,700 expense paid by the Lancaster Chamber of Commerce.

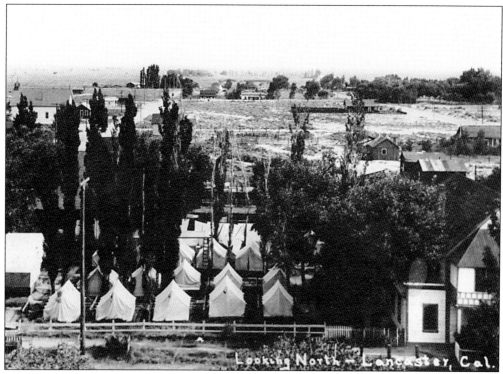

This view looking north past a "tent city" at the Western Hotel was probably taken from atop the bell tower at the old grammar school *c.* 1914.

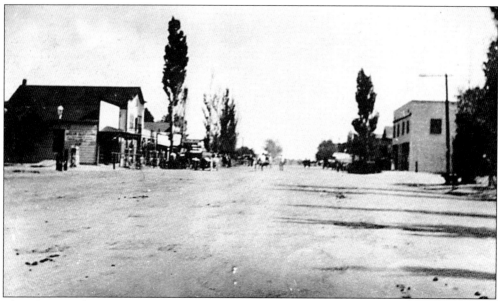

This photograph, taken in the middle of Tenth Street looking east toward Antelope Avenue, shows downtown Lancaster around 1914. The wooden building to the left by the gaslight was Mom Evert's building and the two-story brick building across from it was a hotel annex, which burned in 1919. The Western Hotel would be immediately to the left (north) and the third Lancaster Grammar School, a two-story brick building, was to the right (south).

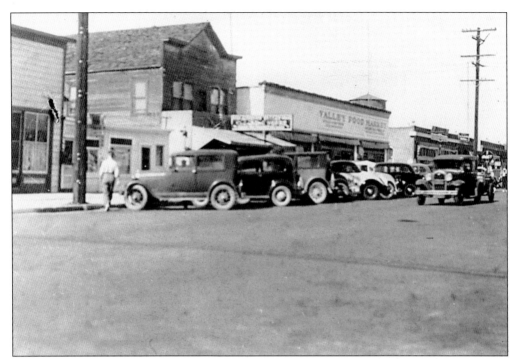

This photograph shows basically the same location on Tenth Street about 25 years later. Many of the old buildings remain, although the owners and types of businesses have changed.

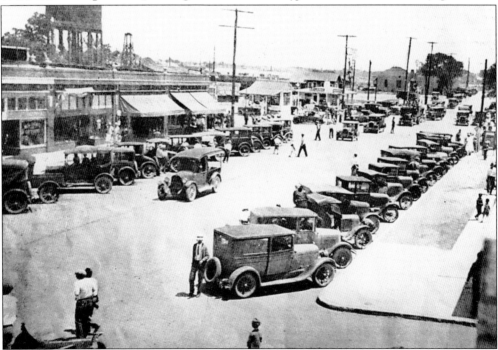

Lancaster was the hub of commercial activity for the Antelope Valley during the 1930s, as illustrated by this very busy weekend afternoon on Tenth Street just west of Antelope Avenue. It was the time to shop, enjoy a movie, pay bills, and visit with friends.

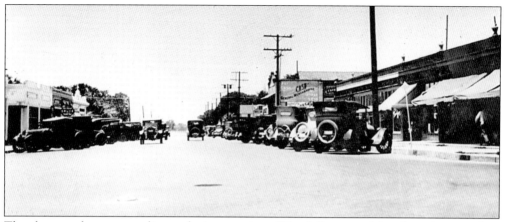

The photographer was standing at the intersection of Tenth Street and Antelope Avenue when he took this image looking west.

A lonely "guest" looks out of the window at the old Lancaster Jail, c. 1914. This jail, which was used from the 1880s to 1916, was located behind Trusty's Oak Bar on Antelope Avenue, the same site as the present-day (fourth) sheriff's station. Here, Judge Bulkley locked up hobos, drunks, cattle rustlers, and gypsies. Instead of giving names like John Doe, prisoners often identified themselves as "John Lancaster." The eight-by-ten-foot, two-cell jail had no furniture, only a dirt floor. As the door was often left unlocked, jailbreaks were frequent.

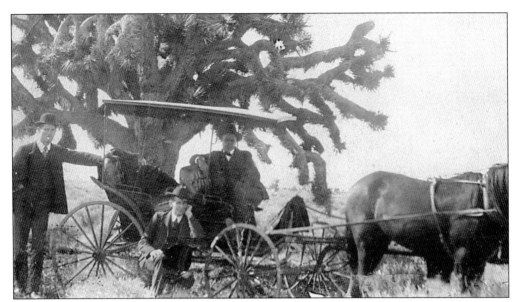

Constable Ed Cummings (kneeling) poses with realtor Frank Rutledge, who is trying to sell butcher Ted Knoll some land. In 1925, Cummings and four deputies formed the entire police agency of the valley. In the old days, a constable's salary was $30 per month with a bonus for each arrest, not to exceed $100 per month. During Prohibition, Cummings spent his workdays driving across the valley in his Studebaker, sniffing for booze. He found lots of corn whiskey.

The 1953 "class" of newly assigned sheriff's deputies poses proudly at the sheriff's station at the Los Angeles County Complex at Cedar Avenue and Lancaster Boulevard. Lancaster's second jail was located at this site. Built at a cost of $2 million, a third sheriff's station was later built at Tenth Street West and Avenue J. The present-day sheriff's station has returned to the site of the first Lancaster jail.

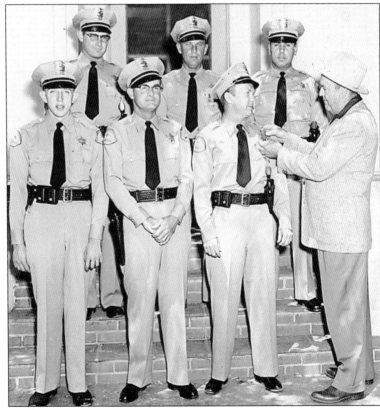

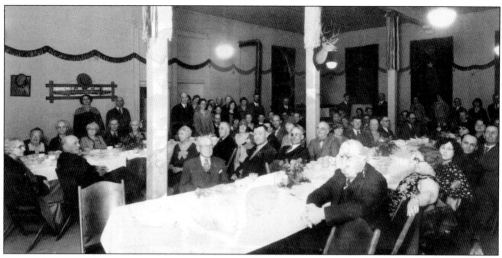

Residents of Lancaster and all of the Antelope Valley attended the farewell dinner for popular Antelope Valley judge Olcott Bulkley (front right) and his wife in 1930. Judge Bulkley presided over the most important local court cases. The dinner probably took place at the Lancaster Inn.

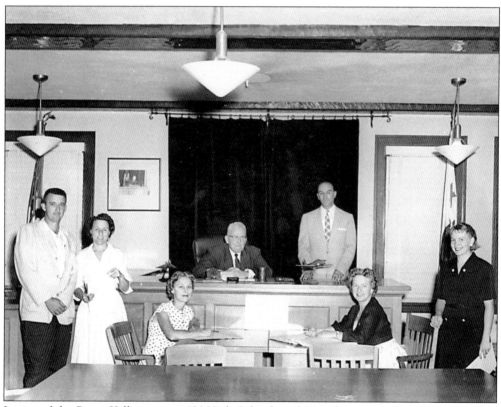

Justice of the Peace Keller was an AV High School graduate who returned to the valley after law school and also served as a road commissioner. He is pictured with his staff at the Antelope Valley Courthouse in the county complex in 1959.

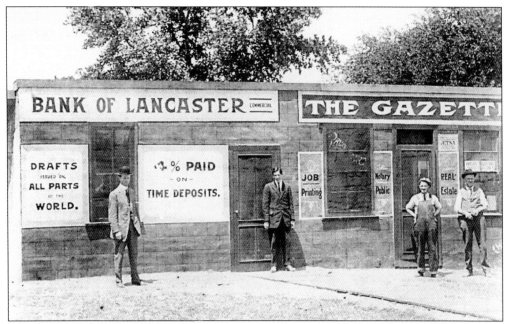

The AV Bank, the first bank in Lancaster, opened in 1891 in a general merchandise store. When a fire destroyed it in 1894 the town was without a bank until 1912, when J.W. Jeal started the Bank of Lancaster on Antelope Avenue. One year later, George Fuller and others established the Farmers and Merchants Bank. These two banks were soon united and became known as the Antelope Valley Bank in 1915.

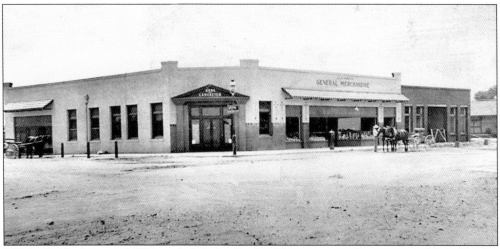

J.W. Jeal's block around 1912 included the Bank of Lancaster in the center and J.A. Varela's General Store to the right. These businesses were located east of the train depot on the southwest corner of Tenth Street and Yucca. Note the gaslights. Today this building is home to Healy Glass. The modern store's interior still boasts several features dating from the old bank.

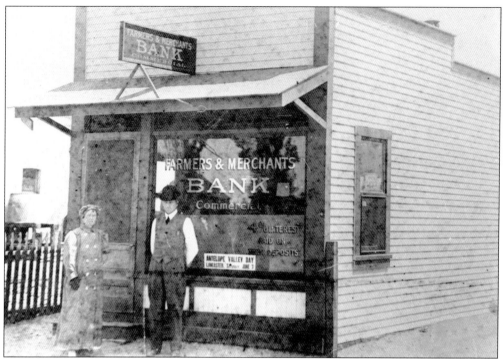

The Lancaster branch of Los Angeles–based Farmers and Merchants Bank was located in a small building on the southeast corner of the alley and Tenth Street between Antelope and Beech Avenues. The Antelope Valley Bank eventually took over the old Farmers and Merchants Bank building and in December 1931, the Bank of Italy (later the Bank of America) bought out Antelope Valley Bank. This was the only bank in Lancaster during the 1940s.

The old Bank of America building, shown here before the structure was demolished to make way for the new sheriff's station, stood at the northeast corner of Beech Avenue and Lancaster Boulevard and went through several owners. Originally this spot was home to Mom Evert's maternity home/hospital.

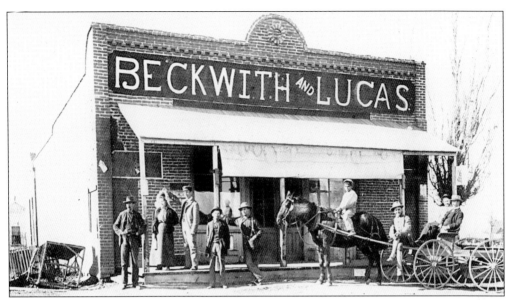

The popular Beckwith and Lucas General Store occupied a prime location on the southwest corner of Tenth Street and Antelope Avenue. At the far left is the *Lancaster Gazette* office. Note the early telephone sign on the post by the wagon. In 1889, residents wrote a poem about Lancaster: "Lancaster is a booming town, as everybody knows. Two saloons and a grocery store, and a place to wash your clothes!"

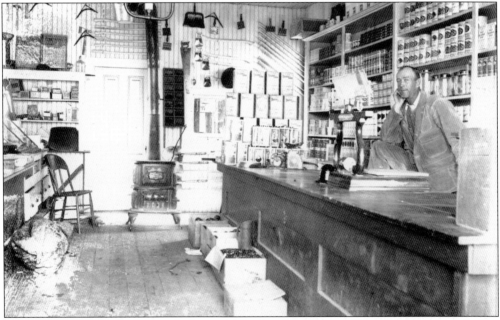

Sneaking a peek inside Cammer's General Merchandise Store in December 1918 reveals that these establishments provided many of the comforts and necessities for pioneer towns. The main location in Lancaster for shopping was at the southwest corner of Antelope Avenue and Tenth Street, although other stores existed elsewhere. One store had a very regional saying in 1891: "Did your aunt elope? It is none of your business if she did. It is our business to give you a bargain."

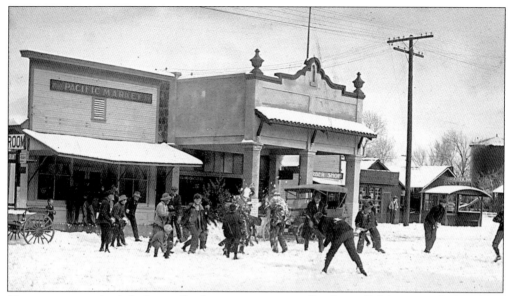

Contrary to popular belief, it really does snow in sunny Southern California, and sometimes quite heavily in the desert. Lancaster, located in the high desert at an elevation of 2,356 feet, has experienced its share of snowstorms. Sometimes the snow only lasts a few hours, but at other times it can remain for days. This is the northwest corner of Tenth Street and Antelope Avenue on December 29, 1916—a great day for a snowball fight.

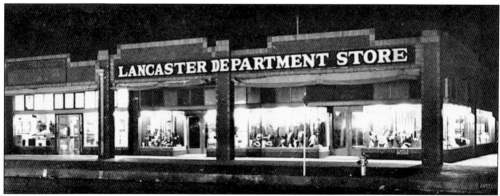

The Lancaster Department Store was established in 1908 at another location, but moved here to the southwest corner of Antelope Avenue and Tenth Street (the old Leo Harris store). The store's motto was: "With our heart and soul in this Valley we are constantly doing our bit to render a SERVICE to you entirely satisfying." Customers also received S&H Green Trading Stamps, which could be redeemed with catalog merchandise.

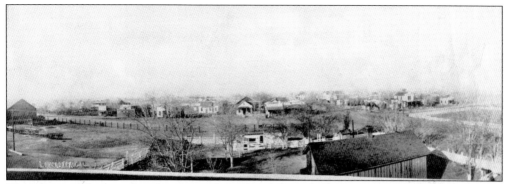

This photograph was taken from atop the railroad depot looking west at downtown Lancaster c. 1910. In 1912, a devastating fire destroyed the two bars, the Cram General Store, and a private residence on the right side of the street, which is now the site of the Los Angeles County Sheriff's Department. During this fire the AV *Ledger Gazette* office between Tenth and Eleventh Streets also went up in smoke, destroying most of its old newspapers.

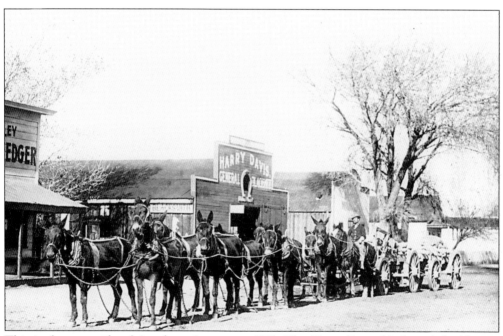

This is the west side of Antelope Avenue, c. 1910. The Harry Davis blacksmith building is located roughly where the driveway entrance to the City of Lancaster Museum/Art Gallery exists today. The board (behind the first mule from the left) shows samples of portrait photos, which could have been taken at the *Antelope Valley Ledger* office next door.

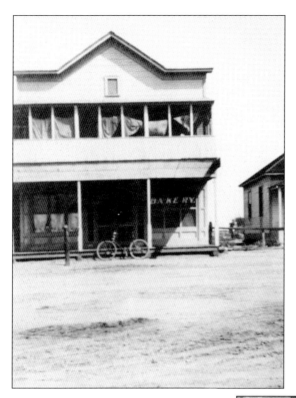

An expert at baking bread, Susie Oldham made more than 95 loaves a day, which she baked in an outdoor oven. She also made her own yeast cakes and sold them locally and in Los Angeles under the trade name "Queen Yeast." Her bakery business grew so large that she hired a baker and started a bakery shop on Tenth Street, which operated for more than four years before being sold to George Lindner.

A member of the Scates family and Howard Jones take a break from the Lancaster Bakery and restaurant on Tenth Street. This structure survived until about the late 1940s or early 1950s. Members of the Scates family still reside in the Antelope Valley. They were also involved in well-drilling and education.

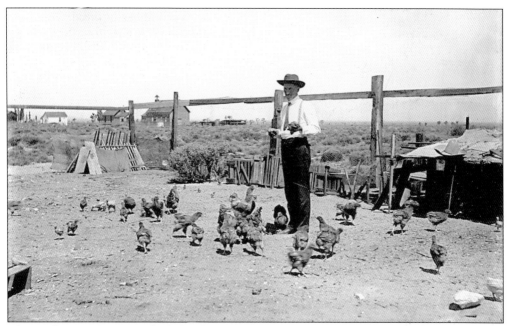

This well-dressed pioneer feeds his hungry chickens. Just left of the center is Sacred Heart Catholic Church, Lancaster's first church. The church was established c. 1887 by Father Bannon. James P. Ward donated the land, and all of the parishioners had a hand in the construction of the building, which could seat 150 people.

Some of the pioneer structures lasted for many years before they were demolished and new ones took their places. This building was also known as the old Carter Barn.

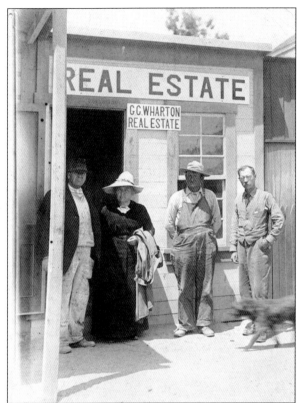

Alice Adams Rutledge is often called the "Mother of the Antelope Valley" because of her extensive real estate practice. She and a partner had an office in Los Angeles where she handled AV land transactions. When she had prospective customers, she would travel on the night train to Lancaster with them and hire a wagon to see the land. Her first office was at Mom Evert's place and then in an office by the railroad depot. Real estate proprietor G.C. Wharton is the third person from the left.

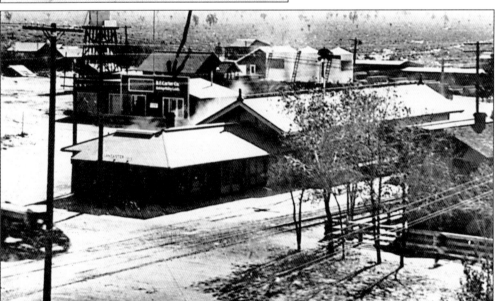

This photo was taken atop the railroad's water tower at the northeast corner of Antelope Avenue and Tenth Street in the late 1920s or early 1930s. Visible to the southeast is the B.F. Carter Company (with the arrow), the railroad depot, and the section foreman's house farther south. On several occasions, residents wanted to hang some criminals from the trees in this area, but that never happened.

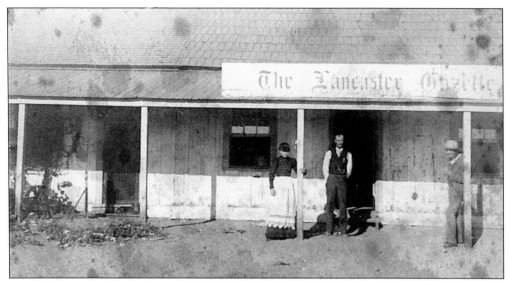

The first weekly newspaper was probably the *Lancaster News*, launched between 1885 and 1886. The next paper was the *Lancaster Gazette* published by Leo Issacs, who sold it in 1888 to S.A. Drummond, a Methodist minister. The first issues were printed in Los Angeles. When Drummond came to town, he formed a partnership with E.Y. Cammer. There was an argument between the two and the partnership split. Cammer (in the white shirt and vest) remained with the *Lancaster Gazette* and Drummond founded the *Antelope Valley Times*.

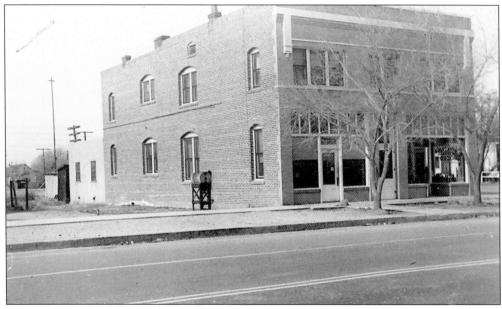

This two-story brick building, photographed on December 30, 1939, is located on the present-day southwest corner of Milling Street and Sierra Highway. Built in 1922, it belonged to Mrs. R.B. Carter Cameron and was known as the Franklin Building, and later housed the *Ledger Gazette* newspaper.

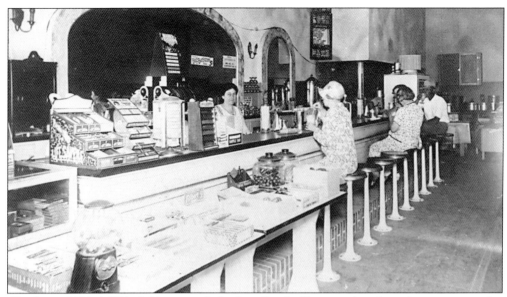

Charles and Ethel Wakefield operated the Jazz Candy Shop on Antelope Avenue, a popular hangout for teenagers and local business people, as well as a favorite spot for young Judy Garland, as it was located near the Valley Theatre. In February 1920, the *AV Ledger Gazette* described Charles Wakefield as "The Onlyest Candy Maker in this neck of the woods." A fire destroyed this establishment in July 1935. Ethel Omen is behind the counter getting ready to serve a soda.

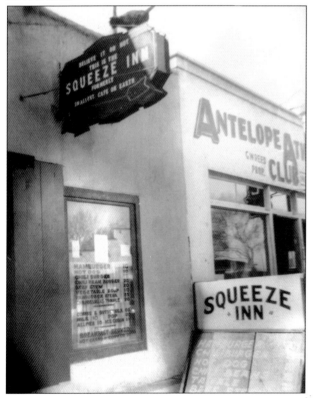

The Squeeze Inn, located next to the Rendezvous Bar on Antelope Avenue, opened in 1929 and once appeared in the *Ripley's Believe It Or Not* strip. It was called the world's smallest café, as it measured only five-by-seven feet with three stools. Because the door was too narrow to admit large customers, owner Guy Moore would sell them a delicious 10¢ hamburger to be enjoyed outside.

The first telephone toll office was installed in 1902 in H. Pierce's store at the southwest corner of Antelope Avenue and Tenth Street. Buddy Goodrich started the first telephone company in 1902 with switchboard connections, and had eight subscribers that first year who paid $1 per month for service. This is the telephone headquarters in the early 1950s on Fern Avenue.

Some time between 1903 and 1904, Paul Bachert bought H. Pierce's store and made a separate building for the telephone company, with Mrs. Crane continuing as the town's operator until 1910. In 1919, the telephone company moved to the northwest corner of Tenth Street and Beech Avenue. This is an operator at War Eagle Field during the 1940s. During the late 1950s and early 1960s, the telephone prefix for Lancaster was "WH" for Whitehall.

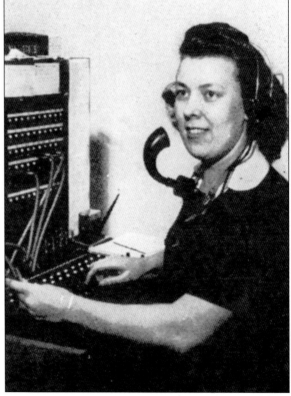

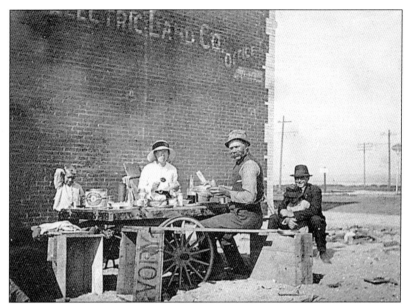

In 1890, three to four gaslights along Tenth Street provided nighttime illumination. The brick wall above reads "Electric Land Co. office." The Pacific Light and Power Company brought the first power lines into the valley at Lancaster in 1914, although some rural areas like Juniper Hills did not obtain electricity until the 1940s. In 1915, Pacific Light and Power was sold to the Southern California Edison Company, which moved into its quarters on Antelope Avenue, by Milling, later that year. Around 1920, the Edison Company assigned street numbers to businesses and homes.

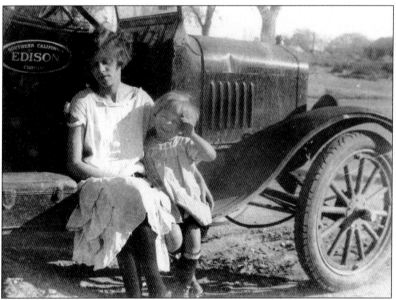

Although Lancaster had electricity in 1914, less than 50 customers were wired, and their service was for lights only. However, service soon grew to 200 homes, of which three had electric ranges. By 1936, over 3,100 customers were wired within the Lancaster division and more than 1,000 electric ranges were in use. Refrigerators were sold by the E.A. Kneip dealership. This lady and her child pose on the local Southern California Edison truck.

As electrical usage increased, so did the number of Lancaster businesses, such as the Antelope Valley Cleaners and Laundry located on Avenue I in 1930. During the Depression, more and more Lancaster women, like women across the nation, entered the workforce to help support their families.

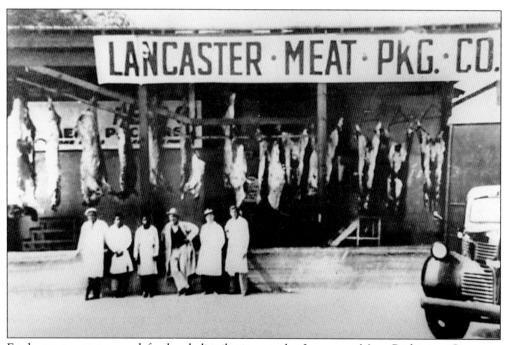

Fresh meat was prepared for local distribution at the Lancaster Meat Packaging Company during the late 1930s and early 1940s.

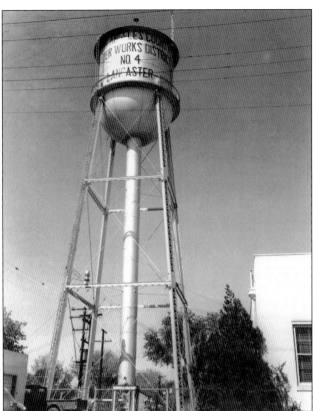

The water tower at the county complex, located on the southwest corner of Cedar Avenue and Tenth Street, became a landmark for valley residents. Built in 1922, it was dismantled in 1972. The second sheriff's station can be seen to the right.

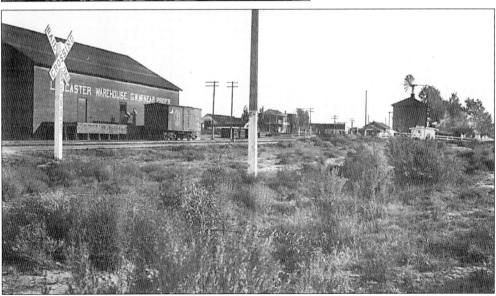

The Lancaster Warehouse was situated along the railroad tracks north of the depot. Lancaster had its own song in 1925: "I love to live in old Lancaster, that dear town so fine, the sunshine pours in our valley, every day is May, making precious hay. Alfalfa's our best bet, our pears are winners yet. For our cream the city begs, our hens lay golden eggs. We'll spread the fame of fair Lancaster, that 'oil' town of mine."

The Lancaster Masons purchased the third Lancaster schoolhouse in 1915 for $4,250 from the B.F. Carter Company, which had secured it from the school district. The building served as a meeting place for the Masons, Eastern Star, DeMolay, and Rainbow organizations. This is the school around 1930, remodeled with some modifications and minus the school bell tower. The Long Beach earthquake damaged the structure in 1933 and it was demolished the following year.

Mr. Huff owned this building on Cedar Avenue, which served as the 1930s headquarters of the Lancaster Wholesale distributors of tobacco and candies.

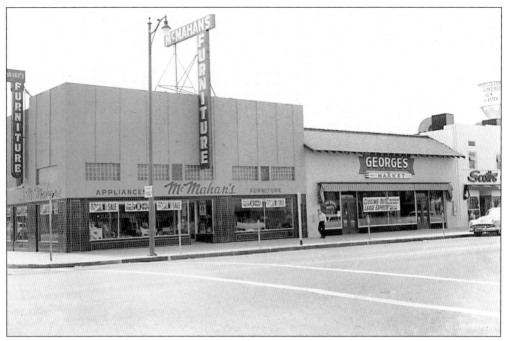

This early 1950s view shows the southwest corner of Beech Avenue and Lancaster Boulevard. Today, the Lancaster Chamber of Commerce is located at the site of George's Market.

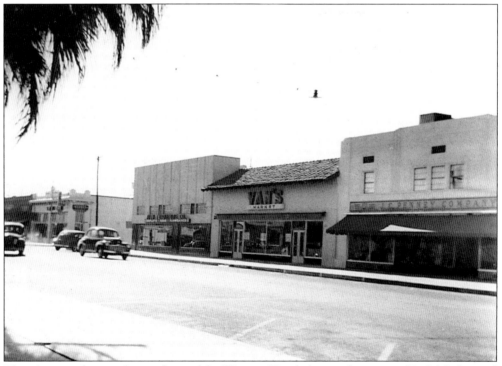

This photograph was taken in front of the Western Hotel. Across the street is Van's Market and J.C. Penney, the first national department chain store in Lancaster, which opened in 1930 on the southwest corner of Beech Avenue and Tenth Street. This was its second location.

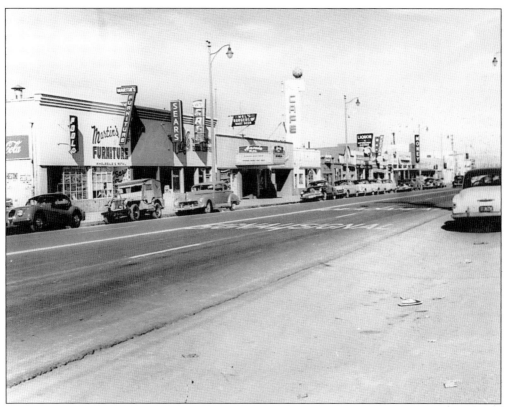

During the 1950s, Antelope Avenue, now Sierra Highway, had a variety of businesses such as Martin's Furniture, Sears, smaller "mom and pop" stores, several cafes and bars, and the Arcade building, which replaced the old Valley Theatre (center).

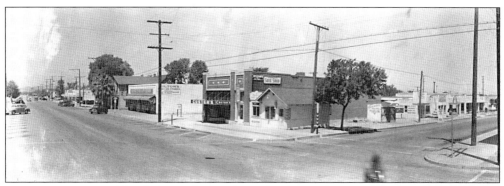

A panoramic view of Tenth Street during the 1950s shows why Lancaster was the commercial hub of the AV. The fifth Lancaster Post Office, a long brick structure, was located two buildings west of the Bank of America.

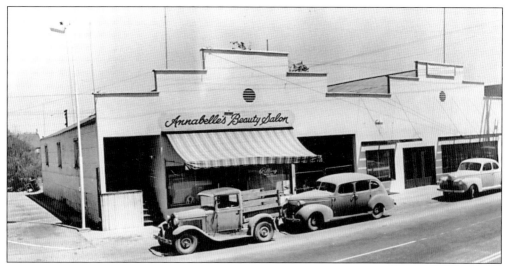

This view of the east side of Antelope Avenue looking south between Tenth and Eleventh Streets was taken in 1938. These buildings have been gone for quite a few years. This area is now the site of the Metrolink Antelope Valley train depot, which connects to various cities throughout Southern California. The Metrolink came to Lancaster in early 1993, following the devastating Northridge earthquake of January 1993, which destroyed part of the AV 14 Freeway. The Lancaster depot is the end of this line.

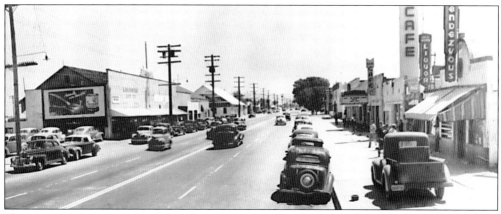

This view of the west side of Antelope Avenue shows the "waterfront" with its several bars. The marquee from the old Valley Theatre is visible on the right side. The old Safeway market building still stands at the southwest corner of Sierra Highway and Lancaster Boulevard.

# *Four*

# PERSONAL GLIMPSES

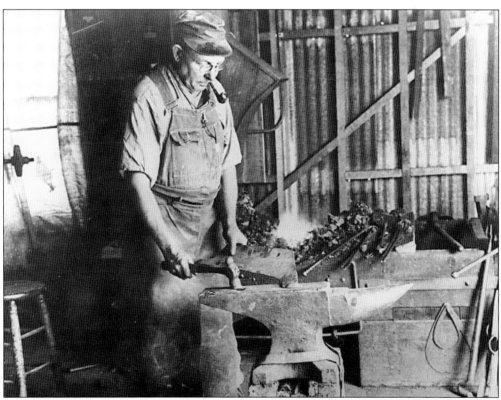

George Black clangs away at his anvil in his blacksmith shop off Beech Avenue and Eleventh Street (Milling Street). As in all pioneer towns, a blacksmith shop was a much needed institution. The blacksmith was kept very busy at his anvil, as horses had to be shod, tools made, and equipment repaired. During the 1890s a good working horse sold for about $25 to $45 in Lancaster.

Lancaster resident Oliver Mitchell is dressed as a Chinese person for a party on February 21, 1903. In addition to building and later working for the railroad, early Chinese workers cut down Joshua trees for an English newspaper company in 1884, became miners, and were involved in local agricultural ventures. Lancaster had a small "tent" Chinatown in 1885. On Lee ran a Chinese laundry and sold potatoes from his establishment on Antelope Avenue from 1885 to the early 1890s.

Looks like young Herbert Keeler wants to help his mother with some outdoor chores on March 21, 1903. Life for pioneers could be difficult, with no electricity, no indoor plumbing, and no heat except by wood. Everybody worked as there were fields to clear, cows to milk, wood to chop, foods to preserve, children to clothe, feed, and educate, and crops to be planted and harvested. Even the youngest children were put to work.

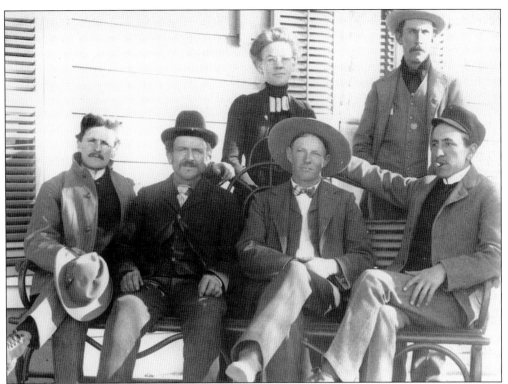

A group of early pioneers relax in some of the latest fashions of the day. Pictured, from left to right, are: (front row) G.O. Francis, R. Atman, G.J. Fonda, and Tom Menzies; (back row) Mrs. and Mr. Wilcox. This group shot was taken on Christmas Day in 1901.

As Lancaster grew and continued to be promoted by newspapers and the chamber of commerce, the town often hosted special guests while they visited "the Heart of the AV." The "Editors of Southern California" and their wives made such a visit on May 23, 1913. Here the wives, wearing the white shirtwaists popular around the time, stand on the steps of the wooden Women's Independence Club Hall.

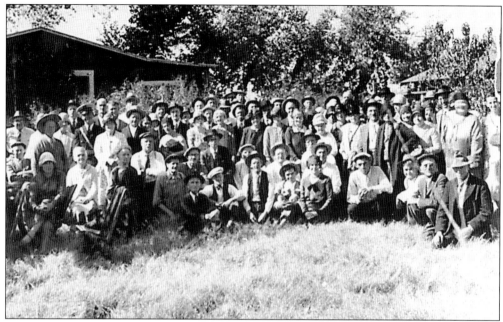

Early pioneers who were proud of the region's history established an event called the "Old-Timers Barbecue," which is still held today on the fairgrounds. Many early settlers would bring their precious photographs to these meetings. One committee member, Ed Cummings, collected them through the years so the valley's photographic history would be preserved. The West Antelope Valley Historical Society has also collected these photographs and shared them with the Lancaster Museum/Art Gallery. This an early meeting held at Locust Gardens in Lancaster.

# FIRST ANNUAL DINNER
# PIONEERS and OLD TIMERS
# of ANTELOPE VALLEY
# SATURDAY, MARCH 31, 1934

### SPONSORED BY GEORGE WEBBER, "JACK" KNECHT
### and GEORGE KINTON
### THE HUSTLING PIONEERS

This is an invitation to the first "Pioneers and Old-Timers Barbecue." Anyone who has lived in the Antelope Valley for 25 years or more is considered an old-timer.

Many early residents left behind photographs of themselves but unfortunately little other information. The caption on the original glass plate negative for this photograph simply states: "Mrs. Garcia of Lancaster—1901." She may have been married to a Mexican railroad worker and lived in the workers' section of town north of the depot.

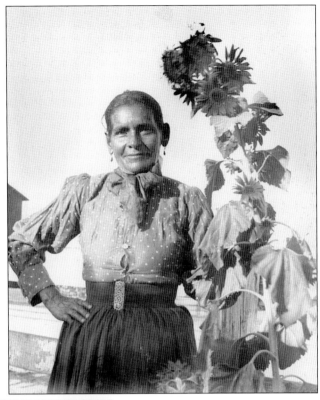

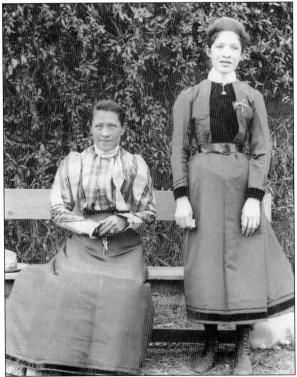

These two Hispanic women, probably mother and daughter, were guests at a Lancaster hotel in 1901. Minority pioneers also contributed to the history of Lancaster. Some of the earliest settlers were Hispanic, while the railroad would not have been built without Chinese workers. In addition, Jewish merchants were vital to the community, Japanese farmers came here in the 1920s, and African-American farmers toiled on their homesteads.

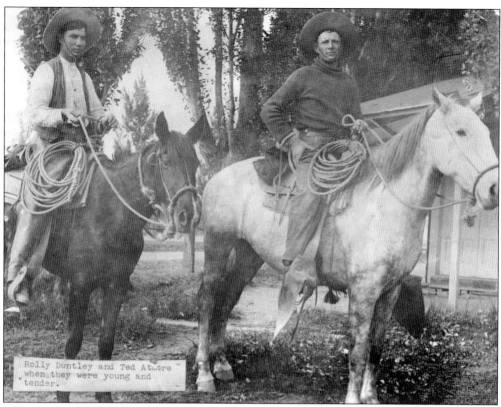

Rolly Duntley and Ted Atmore when they were young and tender.

Dashing cowboys were an integral part of AV's colorful past. Popular cowboys Rawley Duntley (left) and Ted Atmore pose while on horseback in the Rosamond area on October 27, 1902. Close friends, they married their sweethearts in a joint ceremony. Duntley gained famed as the "Barbecue King" because of his Sacred Heart barbecues. A City of Lancaster park near AV College is named in his honor.

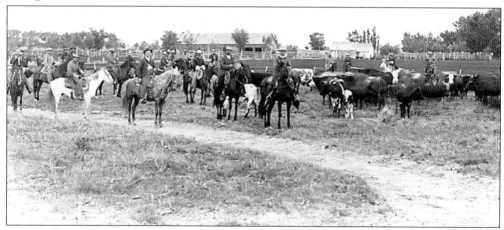

The cattle industry was important in the valley from 1886 to 1910. Most local ranching operations were small scale with the Hereford breed seeming to do best. Harry Butterworth, a leading cattleman and a Lancaster constable, rides his spotted horse, Prince (third horse from left), during a roundup near Lancaster on May 28, 1906. It is said that Butterworth's horse was taken from a herd of wild horses caught in the valley.

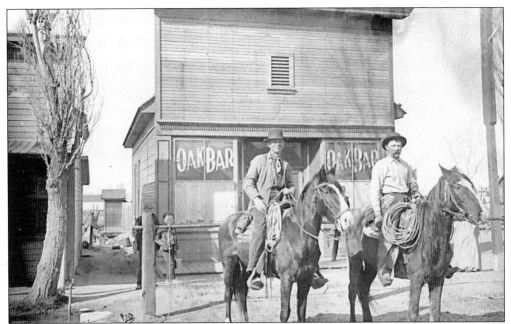

Local cowboys pose in front of the Oak Bar Saloon on Antelope Avenue just north of Tenth Street. Saloons were common in Lancaster; they included Trusty's Oak Bar, Henry Specht's Corner Saloon, Nick Evert's Saloon at Mom Evert's place, and another at the Western Hotel. Still, the town did not compare with old Tehachapi, which at one time had 17 saloons!

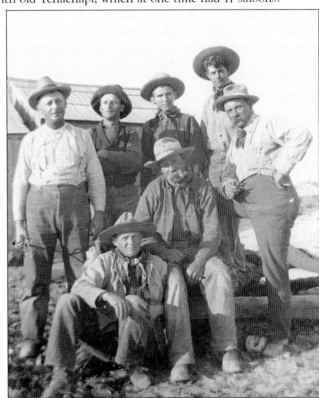

Life at times could be monotonous for local cowboys, but they had fun when they came to town. Saturday night dances and the "bright lights" of saloons in Lancaster or Mojave beckoned these hardworking cowpunchers.

In the late 1880s and early 1890s, Mace Mayes, born in Georgia, served as a constable in Lancaster and also ran a bar. However, he and a nephew, Newton Morris, and several other accomplices were later accused of running a cattle-rustling ring in the AV. Their illicit activities were often conceived in his saloon on Antelope Avenue. Mayes was arrested by Constable Eli Cammer and Judge Olcott Bulkley presided over the early AV's "Trial of the Century" as Mayes's cattle-rustling case in Palmdale was dubbed. The trial lasted 10 days and it is said that about half the population of the valley attended. Mayes served six years in San Quentin, while his nephew later became chief justice of the Georgia Supreme Court. Mayes, on the other hand, did not end his life of crime after his release, for he soon became involved in counterfeiting and was returned to prison.

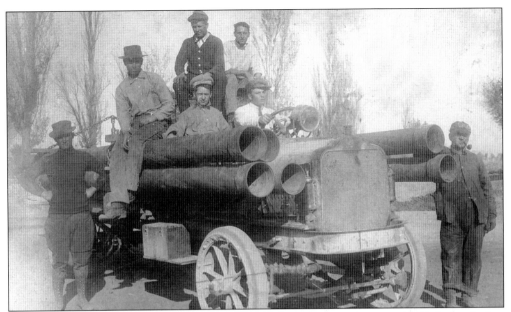

Hal Roach, the movie director of the *Our Gang* comedies, got his start in Hollywood after hauling construction supplies for the Los Angeles Aqueduct, which was being built in the AV. Here he is in Lancaster, on the far left transporting pipes to the Midway Gas Company pipeline in the west end of the AV. The driver is Charles Scates and the helpers are Walter Scates, Charles Alcott, and Ross Bugyandi.

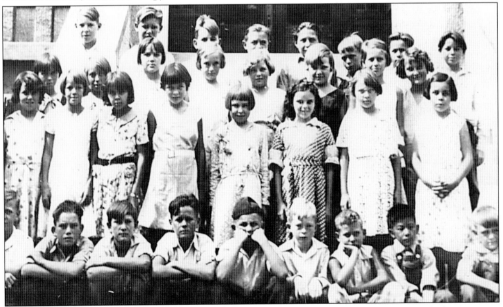

Actor John Wayne (born Marion Morrison) lived in Lancaster in 1914 and attended Lancaster Grammar School. The Morrison homestead was near the present-day UPS facility on Avenue M. Famous actress and singer Judy Garland (born Frances Gumm) resided here from 1928 to 1934. She received her first stage experience in Lancaster at the Valley Theatre, which her father owned, and later performed all over the AV. In this Lancaster Grammar School photograph from 1932, young Judy is in the second row, sixth from the left.

Famous aviatrix Florence "Pancho" Lowe Barnes (left), "Spade" Cooley (second from left), and guests relax in Rosamond sometime in the 1950s. Pancho, who lived at Muroc Army Air Force Base (now Edwards AFB), could often be seen in Lancaster riding her motorcycle while dressed in men's attire. She had the contract for teaching civilian air pilots at AV College from 1941 to 1942. Willow Springs resident Cooley, a gifted fiddler, popular recording star, and TV personality, was also a frequent visitor to Lancaster.

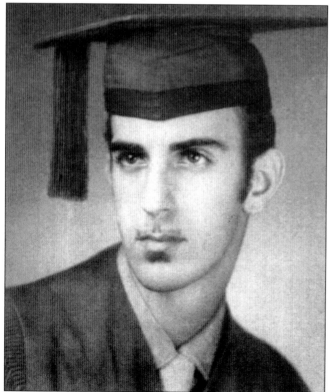

Musician and composer Frank Zappa lived in Lancaster and attended AV High School and AV College. He rose to fame as part of the rock culture of the late 1960s and released 40 albums with his band, the Mothers of Invention. A high school buddy of his was fellow 1960s musician Don Van Vliet, who was better known as Captain Beefheart. This is Zappa's 1958 high school graduation photo.

*Five*

# FUN AND GAMES

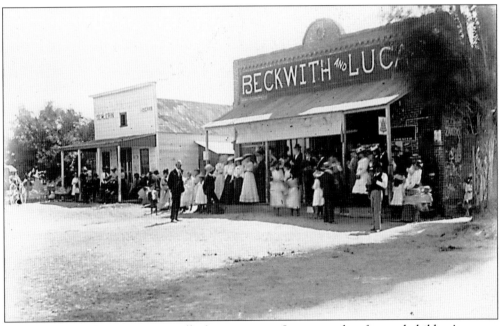

The Fourth of July was an especially festive time in Lancaster that featured children's games, bands playing patriotic songs, picnics, an afternoon baseball game, and a wrestling match. At night there was always a big dance. People would come from 50 miles away for the fun-filled day. People here are gathered at the Beckwith and Lucas General Merchandise Store located on the southwest corner of old Antelope Avenue and Tenth Street, *c.* 1905.

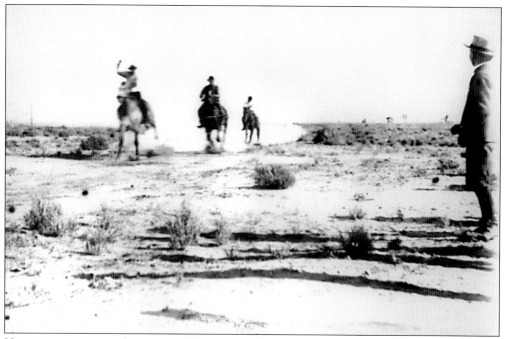

Horse races were another popular Fourth of July attraction. Riders would race bareback for about a quarter mile down Tenth Street heading west from Antelope Avenue to Date Avenue and back. Miner Ysidro Ruiz was the lucky winner in this 1902 holiday race.

Friends, relatives, and fellow church members of the pioneer Benjamin F. Carter family enjoy a Sunday school picnic on the Carter ranch north of Lancaster c. 1906. This site, which will soon be a city park, was at one time considered to be very far away from downtown Lancaster. Members of the Carter family still reside in Lancaster.

During the summer fair, farmers would bring in bales of hay and high school boys would play "hooky" constructing the "Hay Palace" in four to five days. The fairgrounds were located at the present-day northwest corner of Avenue I and Tenth Street West. Inside were agricultural and commercial displays. Sometimes small planes would land near here during the fair. This palace dates to 1919.

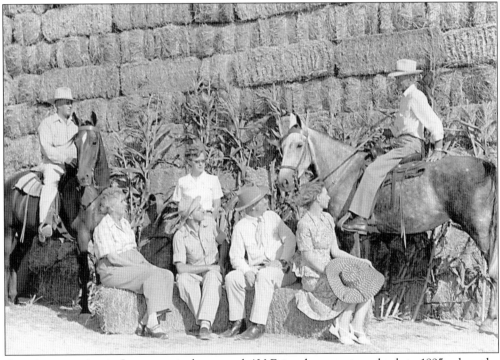

A major attraction in Lancaster is the annual AV Fair, whose roots go back to 1895, when the AV Association sponsored a two-day celebration for area ranchers and farmers. Established as an annual event in 1931, the AV Alfalfa Festival was a way of promoting the valley and its agricultural products. The fairgrounds were located at Avenue I and Division Street; in 2004 the fair opened at its new location off Avenue H and the AV 14 Freeway.

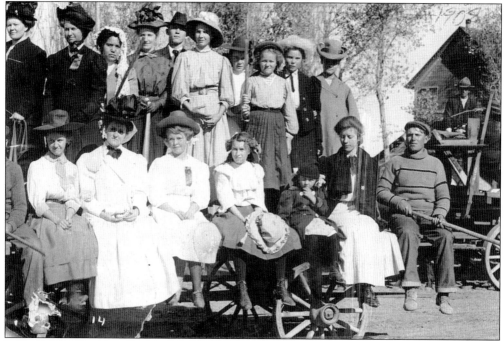

These Lancaster residents and visitors near the Western Hotel are off to a rabbit hunt. Jackrabbits caused many problems for early farmers by destroying crops, and rather than using poison, a popular means of exterminating them were Sunday "rabbit drives." People would come from all over Southern California to either shoot or club rabbits to death. Girls, boys, women, and men all participated in these drives.

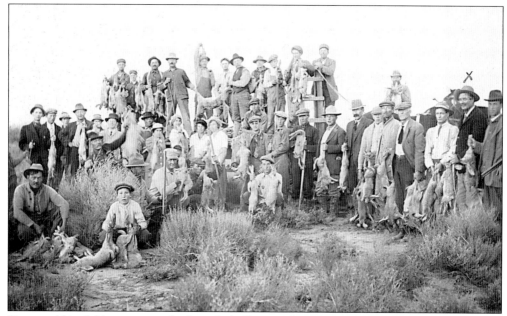

Happy rabbit clubbers pose with their day's "bunny" loot in 1910. Participants would usually head back to Lancaster for a delicious rabbit barbecue. Leftover rabbit meat was sent to orphanages in Los Angeles. The second man from the right is D.E. Hunter.

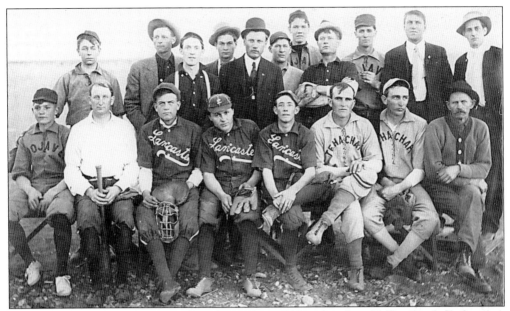

"Three strikes and you're out" was heard as early as 1892 in Antelope Valley. Baseball, the great national pastime, was the most popular team sport in old Lancaster. Because few recreational activities existed for young men to pursue, they would play ball daily for hours. With so much practice, they obviously became very good players. The players in this c. 1910 photo are from Lancaster, Mojave, and Tehachapi teams.

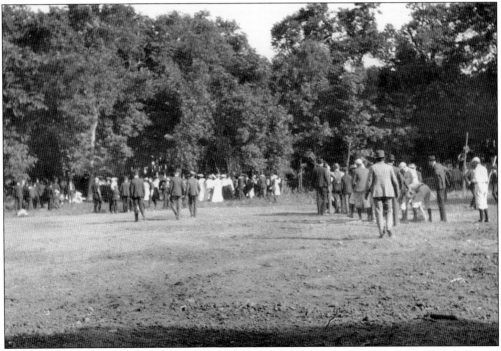

An early baseball game and barbecue take place at Rawley Duntley's Oak Creek Ranch near Willow Springs. People did not want to miss these fun events and would come from all over the Antelope Valley to attend them.

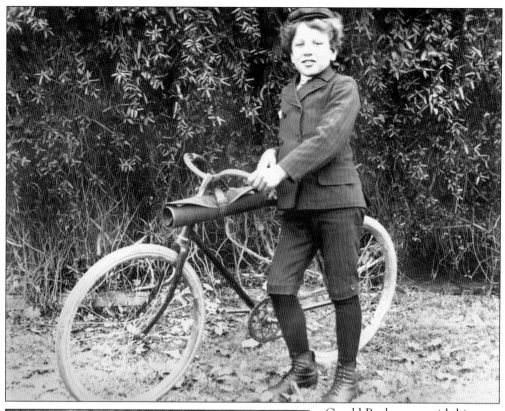

Gerald Poole poses with his new bike—the latest model—while staying at the Lancaster Hotel in 1903. He was the son of Mr. and Mrs. H.A. Poole, who owned the nearby El Dorado Mine.

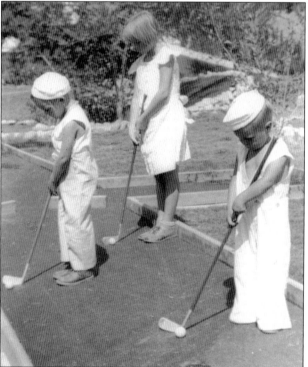

Life in a small town had its fun. As Lancaster grew, the forms of entertainment became more numerous and elaborate. These children enjoy a game of miniature golf in the 1930s. During the Great Depression, several local families opened up miniature golf courses in their backyards as a means of extra income, charging 5¢ per person.

Two women double up on a donkey for a fun ride in 1902. Ponies, donkeys, and pony carts were very popular for entertaining the children of rural Lancaster. These animals often were part of the family.

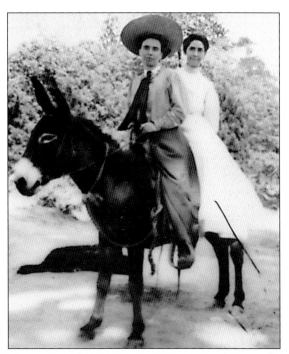

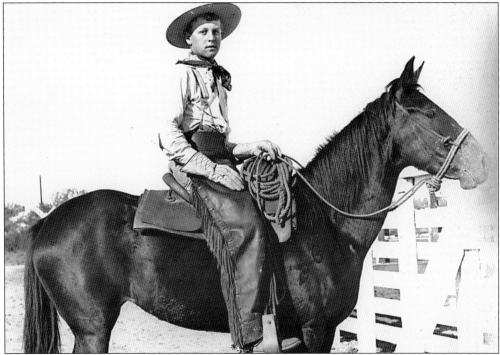

Young R. Atmore sharpens his cowboy skills, c. 1902. In the desert, with its wide open spaces and towns located many miles apart, horsemanship was an important part of everyday life for anyone who wanted to get around. When young Marion Morrison, who later became the famous actor John Wayne, lived in Lancaster (in 1914), some ladies complained that his horse was too skinny and that he had mistreated it. Of course, this was not the case.

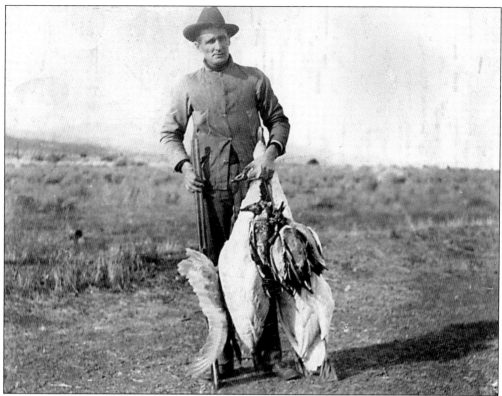

E.E. Cummings hunted near the Palmdale reservoir for these geese and ducks in 1905. During the 1889 Christmas season at the Western Hotel (then the Gillwyn Hotel), the *Lancaster Gazette* reported a special dinner of baked swan for the hotel guests. The meal was prepared by Miss Constable, the daughter of the proprietors.

Sports have been a lively part of life in Lancaster for athletes and cheering crowds since the earliest days. In this 1919 image, the AV High School football team has just defeated Harvard Military Academy, 24-0. The football field at the time was behind the area of the future swimming pool. In 1917, the AV High School football yell was: "Hit 'em in the eye, Sock 'em in the jaw, Drag 'em to the cemetery, Rah! Rah! Rah!"

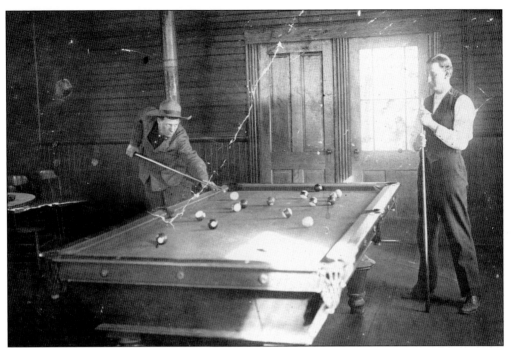

Saloon owner Red R. Trusty and George Atmore play pool in the Oak Bar on Antelope Avenue. Before owning a bar, Trusty had been a night telegraph operator for the Southern Pacific. In addition to alcoholic drinks, some saloons sold tobacco goods and ginger ale. The saloons had old-fashioned swinging bar doors where little children would look underneath to peek inside. And, of course, ladies never entered these establishments.

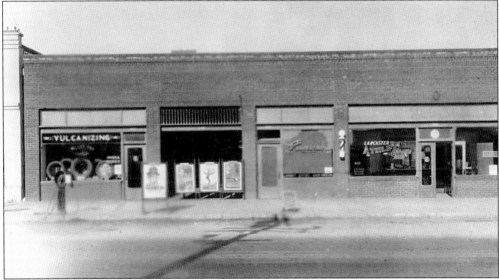

The Lancaster Athletic Club, owned by James Perry Flagg, had billiards and sold cigars, tobacco, candies, and soft drinks. Just a few doors down stood the Antelope Athletic Club owned by G.W. Reed, which offered snooker and billiards. It had gymnasium facilities, which were perfect for professional boxers. This 1927 photo shows, from left to right, a tire store, the silent movie theater, a barbershop, and the Lancaster Athletic Club on the west side of Antelope Avenue.

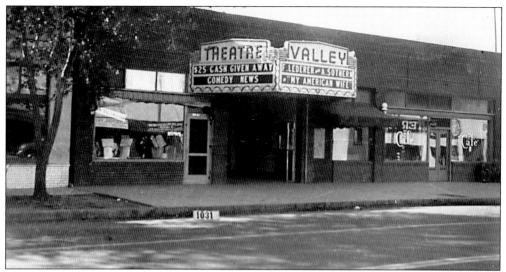

In May 1927, Judy Garland's father, Frank Gumm, leased the old Lancaster Theater, which stood on the west side of Antelope Avenue. He installed a cooling system, replaced the old seats, and changed its name to the Valley Theatre. With its large stage, the 500-seat theatre was the perfect place for the young and talented "Gumm Sisters" to perform. Frank brought the first talkie movie to the AV in February 1930. The theatre burned in September 1953.

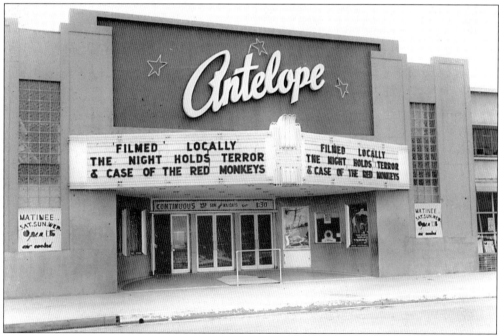

Located next to the AV Bowl, the Antelope Theater, which was built by AV College dean Dave Roach, opened in 1948 with *Mr. Blandings Builds His Dream House*. Before the days of 20-theater complexes with stadium seating, this was the place to see movies in Lancaster. The theater also featured locally filmed movies. The first documented film made here was *Whither Thou Goest* in 1915; it was filmed a few miles south of Lancaster. This theater is now the site of the 780-seat Lancaster Performing Arts Center.

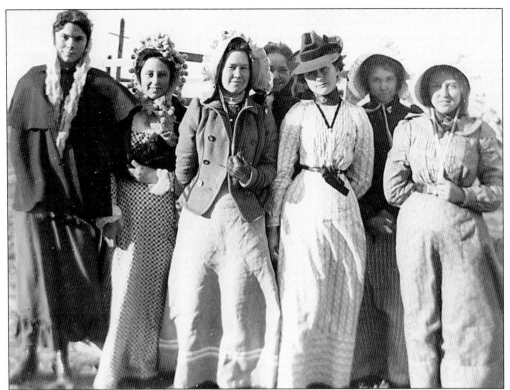

These happy girls enjoy a May Day celebration at old Esperanza in 1900. The girl on the far left is Maggie Evert of Lancaster. Venturing out into the valley's winds must have been risky business for women wearing the elaborate hats of the day. They may have purchased their hats at Alice Adams Rutledge's millinery shop in downtown Lancaster.

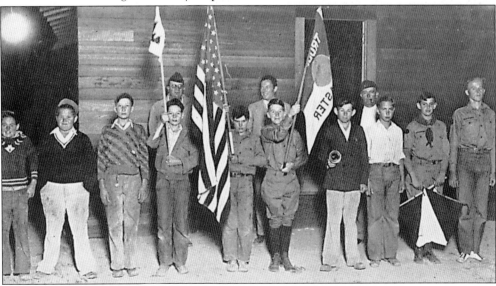

These young boys were very proud to be part of the Lancaster Boy Scouts Troop, c. 1930. The Lancaster Council, Troop 39 was organized by Scoutmaster L.S. Tudor and started with a handful of boys from the grammar school.

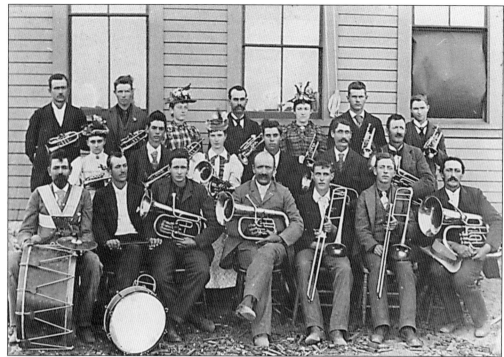

The Almondale Band was the AV's first band which, in 1896, marched from the Lancaster Hotel along Lancaster Boulevard to the old two-story brick schoolhouse for an AV Association and Democrats political meeting. Many of the photos in this book came from the collection of Susie Wright Oldham Davis who is the first person on the left in the middle row. She contributed greatly, through both her personal and business life, to Lancaster's development.

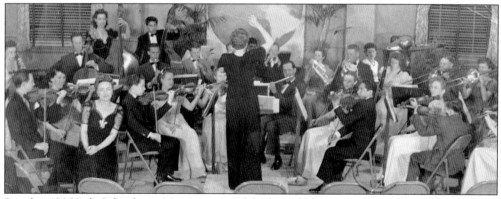

Popular AV High School music instructor Adelaide Ladd Kinnamon conducts the 1940s AV Little Symphony, which presented "Coffee Concerts" at Jane Reynolds Park in Lancaster. She came to Lancaster in 1921 and was known as the "first lady of music in the AV."

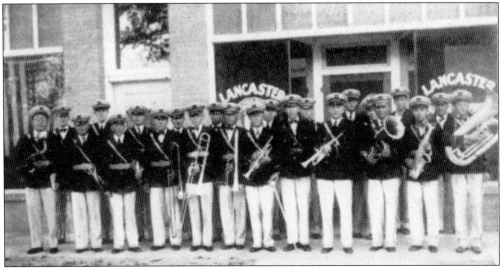

The 25-piece AV Band was organized in the fall of 1926 under the leadership of Paul Hubbard. This band performed with zest and flair at various civic and cultural events in Lancaster and other communities.

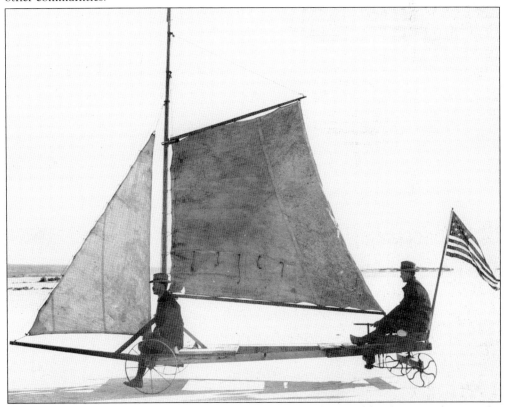

It is doubtful that Lancaster residents participated in windsailing like these gentlemen. The *Desert Queen*, pictured here on Rosamond Dry Lake on February 28, 1902, with what are thought to be miners from the Lida Mine, held the land sailboat record of 62 miles per hour in 1902. Women also went windsailing on the dry lake.

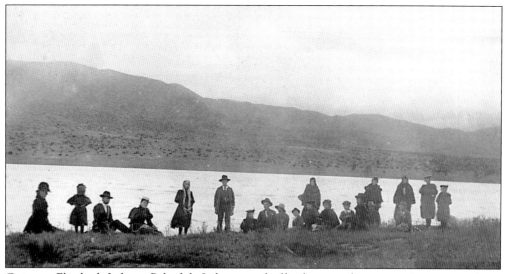

Going to Elizabeth Lake or Palmdale Lake to cool off, take a row boat excursion, or to enjoy a picnic were fun activities for Lancaster residents. However, going to these places could require many hours in a horse-drawn cart. These people are celebrating "Pioneer Picnic Day."

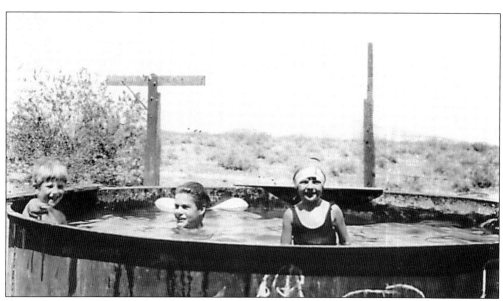

Young Dorene Burton Settle and family cool off in a water tank swimming pool near her house at Tropico. With the desert's intense heat, Lancaster residents would cool off any way they could. Some Lancaster houses had equally inventive "swimming pools."

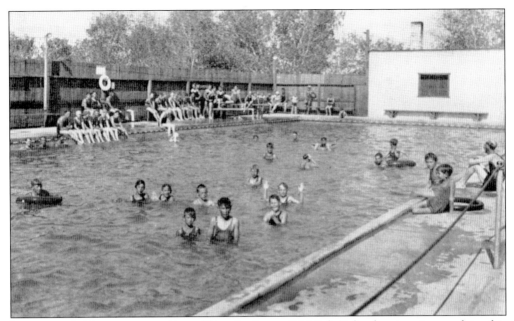

Lancaster children enjoy cooling off in the large AV High School swimming pool in this photo from 1930. With temperatures that could reach 105 degrees during the summer, it was refreshing to have a nice pool in town. This one was built in 1926, and adults were charged 10¢ and children 5¢.

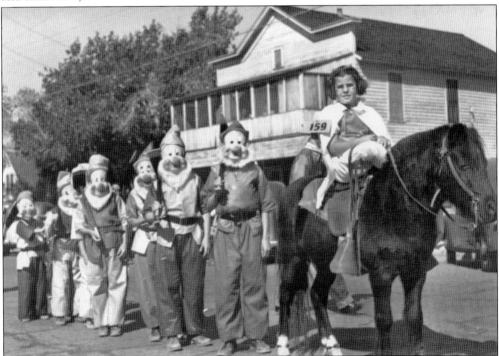

Pattie Carter is accompanied by the "Seven Dwarfs" during a Lancaster parade in this photo from the late 1940s or early 1950s. Note the former Oldham bakery behind her on the north side of Lancaster Boulevard.

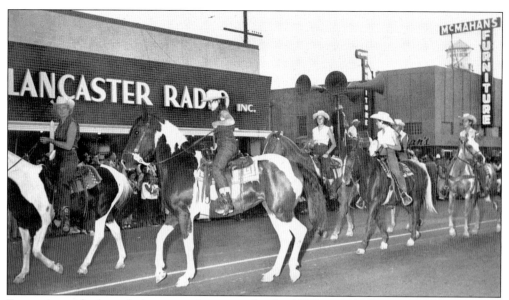

Equestrians ride through downtown Lancaster for the AV Fair in the late 1950s or early 1960s. The old McMahan's building was the site of the first J.C. Penney store in Lancaster. The Lancaster Chamber of Commerce is now located there. The old water tower at the Cedar County Complex is visible at the top right-hand corner.

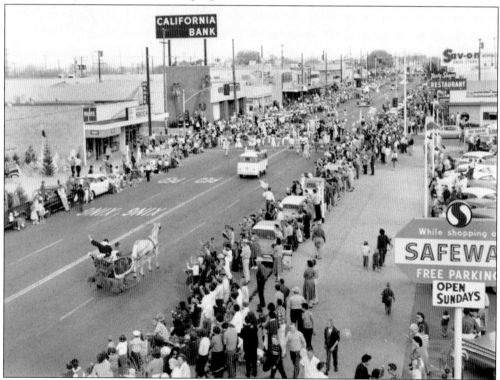

Santa waves to visitors, young and old, on Lancaster Boulevard and Elm Avenue during the downtown Christmas parade in 1959. The Lancaster Chamber of Commerce sponsors this annual holiday parade. Rain or shine, crowds still line the streets to see it.

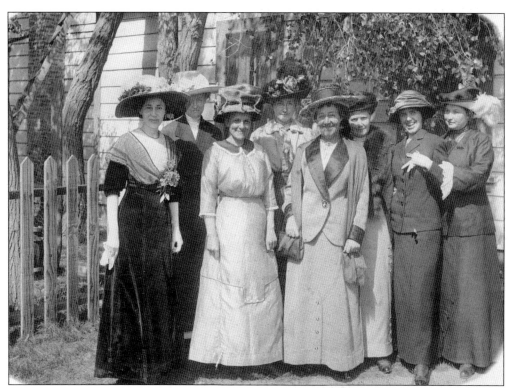

These prominent Lancaster ladies wear their "Sunday best" while attending a progressive luncheon in 1913, which was probably held at the Western Hotel. Shown, from left to right, are Mrs. Loomis, Mrs. Curt Henderson, Mrs. Olcott Bulkley, Mrs. Myrtie Webber, Mrs. John, and three unknown ladies.

Wedding are always festive and enjoyable events. When the very popular Lancaster Grammar School teacher Marie Baker Carter married on August 22, 1935, many Lancaster residents celebrated with the happy couple.

When AV pioneers wanted to have their portraits taken they would usually visit a traveling photographer at his "studio," which would be set up at the Western Hotel or Lancaster Hotel for about two to three weeks. The newspaper offices also took photographs. When a local photographer was not available, residents went to one of the studios in Los Angeles. One of the earliest photographers to capture Lancaster on film was G.L. Albertson; later ones included L.F. Bautier and the Rowland Studio. Famed pioneer photographer Carleton Watkins traveled through this region taking photographs in Acton (the Joshua tree paper mill) and Tehachapi (the Tehachapi railroad loop) in the early 1880s. Shown here, from left to right, are Valyermo area residents Howard Shoemaker, Fred Holmes, Harry Heath, and daughter in 1908.

# Six

# TIME TO REST

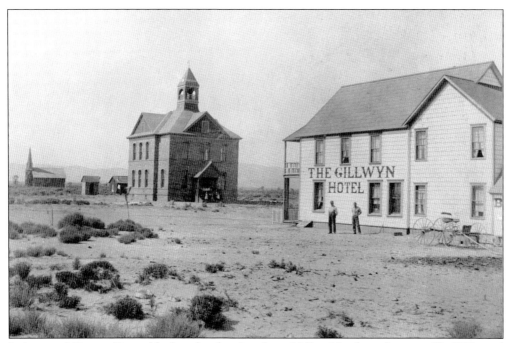

Joshua and Fanny Constable bought the Antelope Valley Hotel on January 15, 1890, and changed its name to the Gillwyn Hotel for unknown reasons. At the time, hotel rates were $1 per day and $6 per week. In this c. 1892 view of the hotel, the new brick grammar school can be seen across the street. In the left-hand corner is an unfinished Protestant church, which was started in 1884 on Beech Avenue between Eleventh and Twelfth Streets.

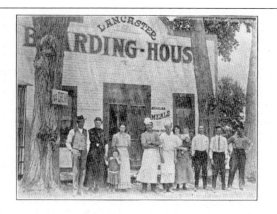

## LANCASTER
## BOARDING HOUSE
### AND
## RESTAURANT

Regular Meals:  6:30 to 8:30 a. m.; 11 a. m. to 1:30 p. m.; 5 to 7 p. m.

SHORT ORDERS 35c and up—Served only between regular meals.

LUNCHES PUT UP          PLENTY TO EAT          QUICK SERVICE

MRS. W. R. JOHNSON

It was very important for a town to have good hotels. Several early hotels included the Lancaster Hotel, the Antelope Valley Hotel, which later became the Gillwyn Hotel and then the Western Hotel, the Lancaster Boarding House, and the Lancaster Inn. This is a 1913 view and ad for the Lancaster Boarding House, which was located on the west side of Antelope Avenue between Tenth and Eleventh Street (Milling Street) in the vicinity of the old Rendezvous Club.

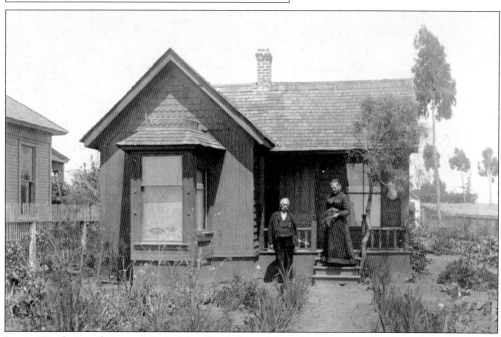

Louis "Rocky" and Anna Maria Von Rockabrand bought an empty lot from James P. Ward (recorded December 3, 1889) and built the Antelope Valley Hotel, which later became the Gillwyn Hotel and eventually the Western Hotel. Rocky was also a restaurant owner, farmer, and a shoe cobbler. In addition to owning acreage in the Antelope Valley, Rocky and his wife bought and sold lots in Redondo Beach. This photograph shows them perhaps at their Redondo Beach house.

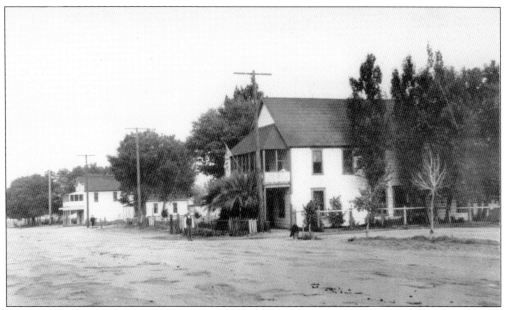

The historic Western Hotel symbolizes the Lancaster of yesteryear. Now a City of Lancaster museum, it is the oldest downtown structure. In this c. 1910 photo, from left to right, are Oldham's Lancaster Bakery, a private residence, and the recently repainted Western Hotel, not long after George and Myrtie Webber purchased the hotel. Nothing really existed beyond the old bakery.

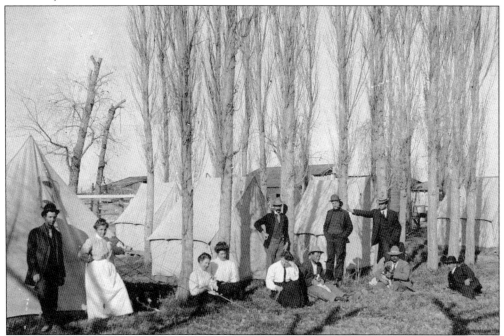

This "tent city" in the Western Hotel's yard may have been set up due to the electric company's need for emergency workers accommodations when the Lancaster Hotel burned in 1914. Note the women, assorted dogs, and even a cat. Hotel owner Myrtie Webber is second from the left while husband George Webber is the man in the middle leaning against a tree.

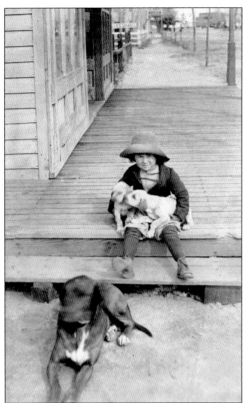

Young Harold Mitchell and some puppies sit on the Western Hotel's porch c. 1908. Concerning dogs, the *Lancaster Gazette* wrote in June 1892: "Dogs run amok in Lancaster. Lancaster might be called dog town. Their number is legion. Their fights and their howls may be heard at all hours of the day. There are big dogs, little dogs, Newfoundland dogs, Poodle dogs, Mastiffs, hounds, coach dogs, and scrub dogs!"

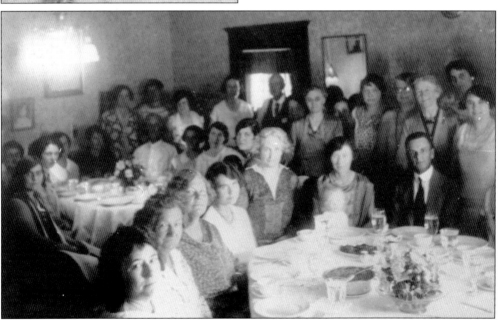

A special meeting and luncheon was held inside the Western Hotel's dining room c. 1912 with George Webber in front of the rear window and Myrtie Webber seated in the center. Myrtie came to Lancaster in 1908 and married George in 1910. She lived to be 110 years old. The Lancaster Chamber of Commerce was organized at this hotel in 1902.

George Webber, shown here c. 1908, arrived in the AV in 1885 as a member of the *London Daily Telegraph* to work on a project that involved cutting down Joshua trees and converting their pulp into newspaper. However, this venture failed as the "paper" rotted, and Webber left the valley for a few years. In 1900, he returned to mine ore in the neighboring Fairmont Township before acquiring the Western Hotel.

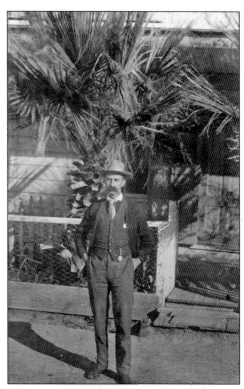

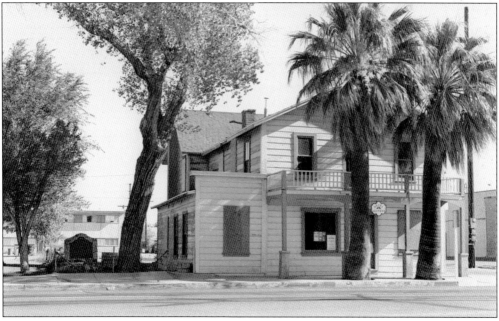

Through the years, the Western Hotel fell into disrepair and was condemned in 1974. Many concerned Lancaster residents, especially schoolchildren, refused to let this historic structure be razed. The Western Hotel Historical Society was formed in 1974 for the purpose of acquiring the property, restoring it, and developing a future museum. Eventually the City of Lancaster was asked to take over the Western Hotel, and a city museum opened in October 1989.

This hotel was located on Tenth Street, immediately east of the Southern Pacific Railroad depot. It was also called the Hotel Lancaster, and accounts differ regarding its original builder. Some say it was built by Edward C. Gillbrand, who came here from Lankershim, England, in 1884. His son, R.C. Gillibrand, was born in the hotel in 1886. Another version states that it was originally a one-story structure built by railroad agent William Storey.

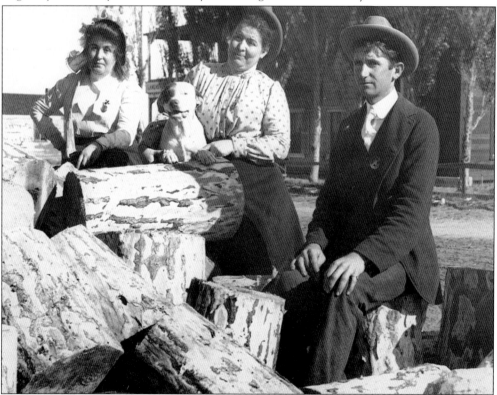

This hotel went through numerous owners, one of whom added a second story. It also had a livery stable, served as a stagecoach stop, and hired out horses and buggies for Sunday rides. Here, Lancaster Hotel visitors, including Hooper the dog, pose by a woodpile on November 18, 1901. A competitor of the Western Hotel, it was destroyed by a fire in 1914.

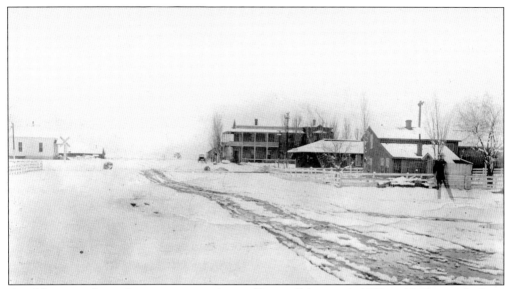

A cold, snowy day in Lancaster is caught on film on February 4, 1903 at 10:30 a.m., looking east from Antelope Avenue and Tenth Street. Mr. Knight's section house, the depot, and the Lancaster Hotel are visible on the right with a railroad house on the left.

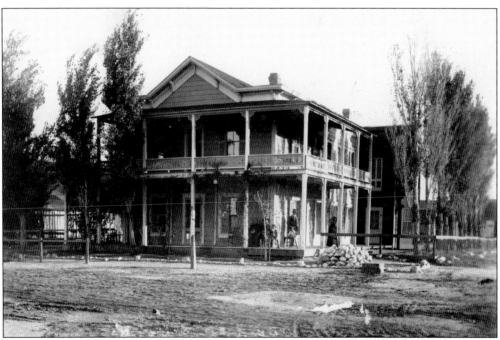

In 1907, a hotel guest could purchase a delicious dinner for only 50¢. The meal included cream-of-corn soup, broiled halibut with Hollandaise sauce, a lettuce salad with french dressing, and creamed mashed potatoes or hot slaw. Entrées included oyster patties, apple fritters with maple syrup, prime rib of beef au jus, or spring chicken with herb dressing. Guests with a sweet tooth could eat deep apple pie or steamed suet pudding with brandy sauce.

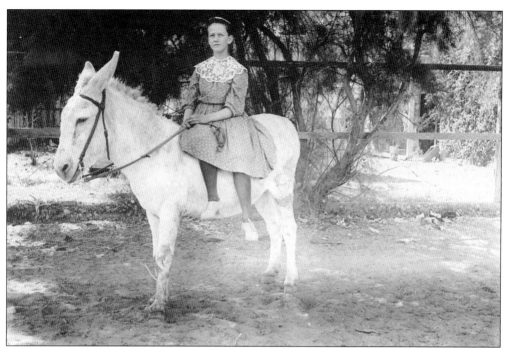

Ruth Tunison holds onto the reins of an easygoing burro named Leon. Her parents ran the Lancaster Hotel in 1905.

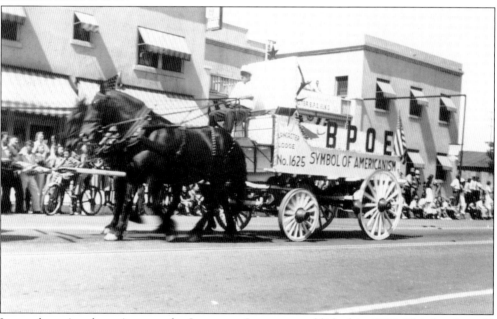

Located on Antelope Avenue, the Lancaster Inn was established in 1919. This hotel could accommodate more guests than the Western Hotel. Dentist Percy Gaskill had his office here during the 1920s. In 1950, the Lancaster Chamber of Commerce office was located in the inn's lobby. Here, Henry Varrieur drives a wagon in the 1939 Alfalfa Festival parade past the inn. The inn and adjoining structures were demolished a few years ago to make room for the new sheriff's complex.

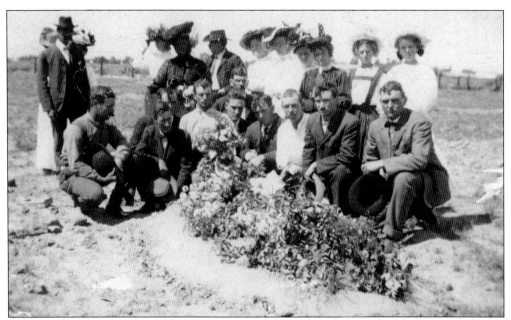

The earliest recorded Lancaster burial took place in March 1885 when a rancher was buried under a Joshua tree on the eastern edge of town. During the 1890s the cemetery was owned by the Lutheran church. In 1902, Alice Rutledge's real estate office handled Benjamin F. Carter's donation of five acres for a new cemetery, the Lancaster Cemetery, which was first used in 1903. This funeral for Leo J. Byrnes took place on September 14, 1908, at the Lancaster Cemetery.

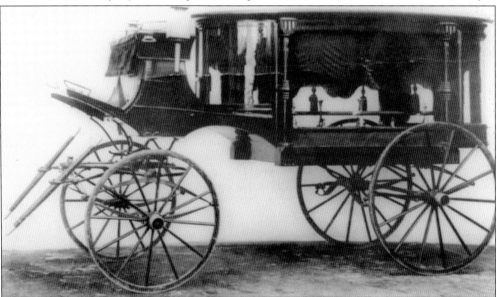

During the 1890s, Lancaster barber Sam McCracken used his barbershop's cellar as a morgue. When he left Lancaster, bodies were shipped to Los Angeles–based embalmers. There was no undertaker in Lancaster until 1913, when Wesley S. Mumaw set up his establishment, which is still in business today. The first horse-drawn hearse in the valley was introduced by the Mumaws in 1916; four years later it was mounted on an auto, making it the first mechanized hearse in the valley.

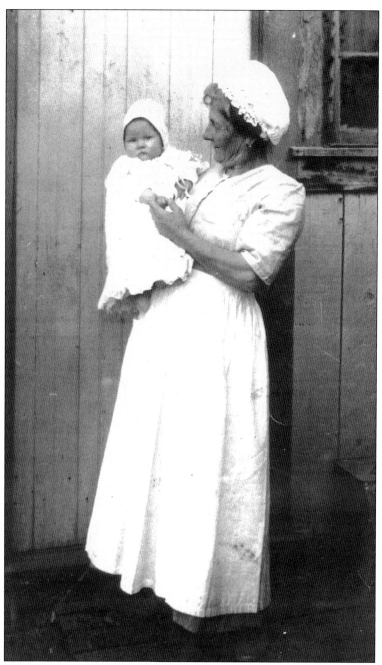

One of the most influential women in the Antelope Valley was Lancaster resident Anna "Mom" Evert, a kindly practical nurse and midwife who took care of local sick people and brought many early valley babies into the world. She delivered many babies at the Western Hotel. She and her husband, Nick, a boot maker and saloon keeper, came to Lancaster in 1891. Mom Evert's house/building at the northeastern corner of Tenth Street and Beech Avenue served as the town's hospital from the early 1900s to 1921. In addition to being a nurse, Mom Evert had an ice cream parlor and worked as a laundress. She hated Nick's saloon and got rid of it as soon as she could. She later left nursing to operate a boarding house on Beech Avenue.

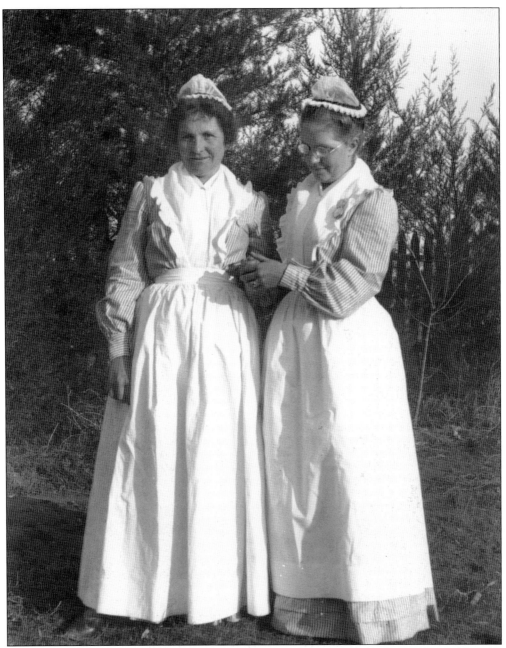

Mom Evert is pictured with another leading Lancaster pioneer, Jane Porter Reynolds, who came to Lancaster in 1896. Jane was a cook at the Western Hotel where she met Maurice Reynolds Sr., who was living at the hotel. Love blossomed and they married in 1897. In 1937, she donated land at Elm Avenue and Thirteenth Street for a park, as she felt sorry for the farmers' children who came to town and had no place to play. This is now a City of Lancaster park with a pool named for her friend, Myrtie Webber. Reynolds, who lived on Ninth Street (Jackman Avenue), is buried beside her husband in the pioneer Lancaster Cemetery located at the northeast corner of Division Street and Lancaster Boulevard. Members of the Reynolds family still reside locally.

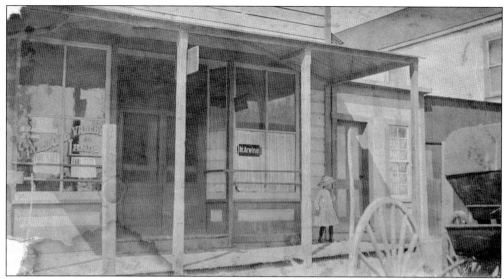

Mom Evert had two important offices in her building on Tenth Street: Dr. James T. Arwine's medical practice and Alice Rutledge's "Antelope Valley Lands" real estate business. Dr. Arwine's office was always busy; however, while Mom Evert delivered most of the babies, Dr. Arwine signed their birth certificates. When Dr. Arwine did deliver babies, he charged $15 for a home delivery in 1912.

Dr. Seth H. Savage also had an office at Mom Evert's place, but when she became ill he decided to build a residence, which also became the town's new hospital as the four front rooms were devoted to patients. By July 1924, there was room for 10 patients. By 1931, Lancaster enjoyed a fully equipped, up-to-date hospital at 233 Tenth Street. Drs. Savage and Percy Gaskill, a dentist, were once featured in a *Ripley's Believe It Or Not* newspaper column because of their unusual "painful" names.

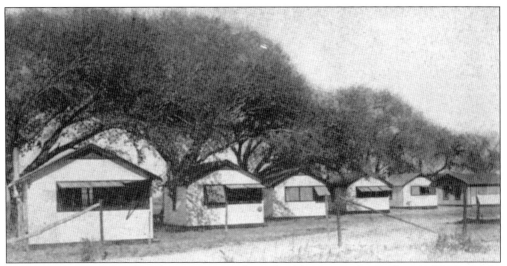

The Lancaster area has long been recognized as a healthy region, being the ideal location for those seeking relief from pulmonary and bronchial problems. The treatment for consumption, or tuberculosis, was rest, good food, sunshine, pure water, and lots of fresh air. By 1904, a number of sick people were living in tents in sections of the valley. The AV TB Sanitarium, which opened in 1924, was located about three miles west of Lancaster while the Kreuger Sanitarium operated on Avenue E.

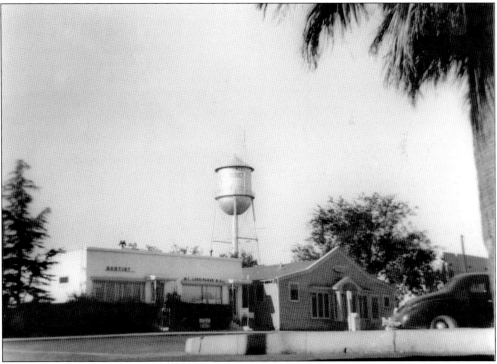

In 1941, Dr. W.R. Senseman took over the Lancaster Community Hospital located on Tenth Street. Also by 1941, there was competition from Dr. C.B. Byrne's hospital located at 315 Tenth Street. In this photograph, the water tower at the Los Angeles County Complex on Cedar Avenue can be seen.

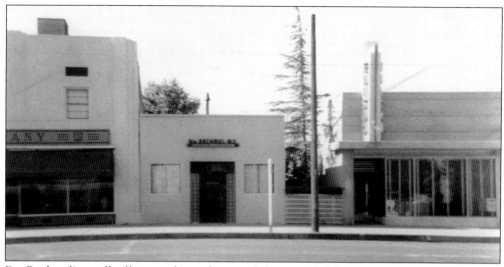

Dr. Rachmel's small office was located west of the second J.C. Penney store and across the street from the Western Hotel. He was considered one of the best obstetricians in Southern California. His motto was "a little toddy for the body."

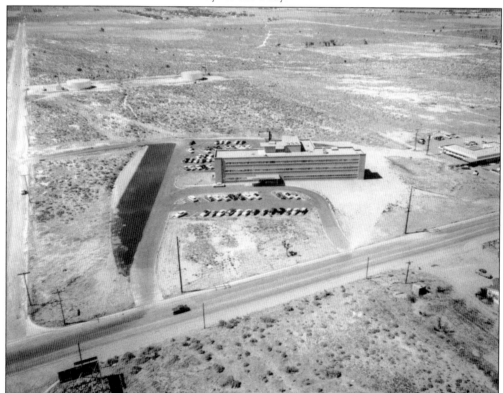

The Desert Community Hospital Association was formed in 1949 with the goal of establishing a community-owned hospital in the valley. Although there were obstacles, the AV Hospital was dedicated on October 1, 1955. Located on nearly 18 acres at the southwestern corner of Avenue J and Fifteenth Street West in Lancaster, it opened up as an 85-bed facility. Total cost was about $1.1 million.

# *Seven*

# GOING PLACES

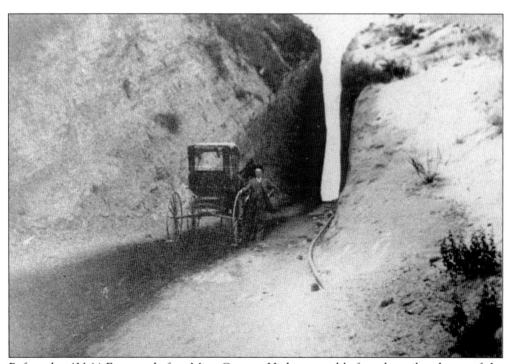

Before the AV 14 Freeway, before Mint Canyon Highway, and before the railroad, one of the main ways to enter the Antelope Valley was through the very narrow Beale's Cut (Fremont Pass) in the Newhall area, which dates to the 1860s. Here, Clarence Gerblick passes through *c.* 1910. The "cut" has appeared in many movies.

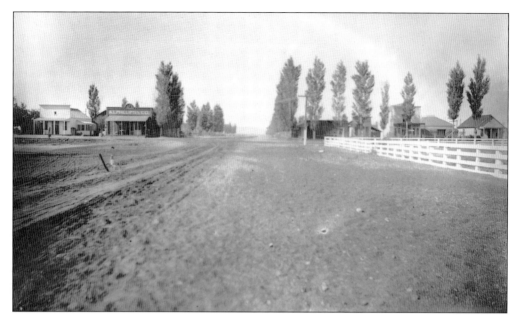

In 1916, Lancaster had two paved streets: parts of Tenth Street and Antelope Avenue. This scene, looking west on Tenth Street by the old railroad depot in the early 1900s, shows the stores and saloons on Antelope Avenue, which was a rough dirt and sand road at the time. The first paved road was started from Saugus and reached the Palmdale area in 1918. In 1921, modern Sierra Highway (Mint Canyon) opened.

Around 1930, Fig Avenue between Twelfth and Thirteenth Streets looks deceptively wide. Streets in old Lancaster were easy to find. Starting at Eighth Street (now Avenue I) and continuing south, the streets were Ninth (Jackman Street), Tenth, (Lancaster Boulevard), Eleventh (Milling Street), and Twelfth Street. Starting at Antelope Avenue (Sierra Highway) and going west were Beech, Cedar, Elm, Fig, and Fern Avenues; modern Tenth Street West was Grape Avenue.

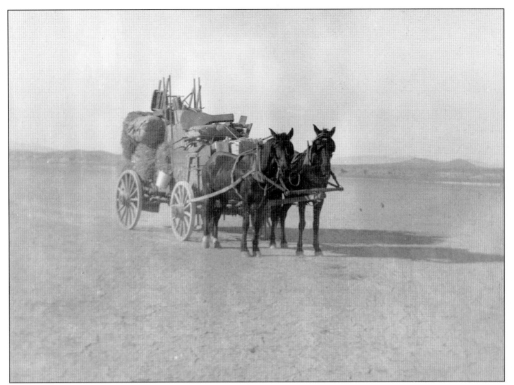

Travel through the desert could be quite lonely as well as dangerous. Heavy winds, sand storms, rattlesnakes, lack of water (or flash floods), and more could be encountered before reaching the "metropolis" of Lancaster. This is a camp/chuck wagon for cowboys in the Rosamond Dry Lake area, c. 1900.

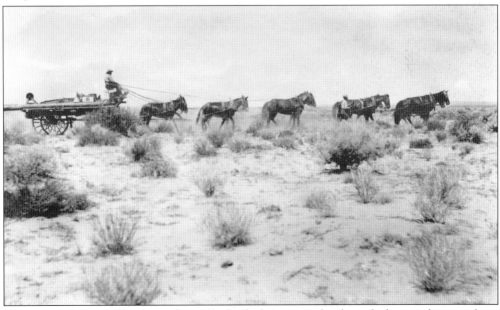

This wagon driver and his co-worker pull a load of pipes or poles through the vast desert perhaps for the Los Angeles Aqueduct.

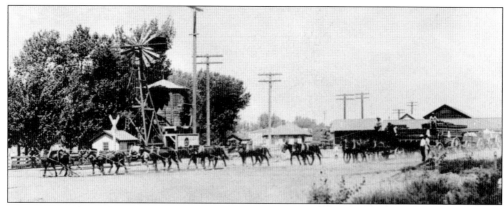

George Lane hauls lumber and cement to the Lydia Weld ranch (Weld was the second woman to graduate from MIT) at Ninetieth Street West and Avenue H. The team is coming from the north on the east side of the railroad track and turning west onto Tenth Street. Today, the water tank is the site of the City of Lancaster's Boeing Plaza featuring an F-4 jet. For more than 50 years, aviators have performed remarkable feats of heroism in the sky over the city of Lancaster. Part of Boeing Plaza, the "Aerospace Walk of Honor" monuments along Lancaster Boulevard celebrate local test pilots such as Jimmy Doolittle, Chuck Yeager, Pete Knight, and Neil Armstrong, among others.

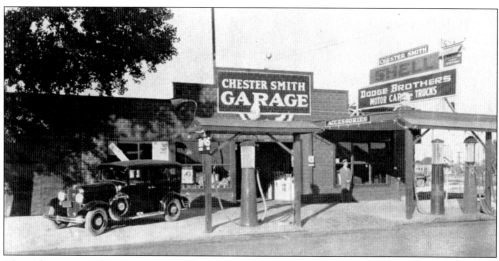

The Chester Smith Garage serviced many early Lancaster automobiles in the early 1930s. Clyde Primmer leased the shop from Smith until Hank Hunter bought it around 1940. A Hank Hunter auto dealership still exists in Lancaster.

Today, the town of Neenach, located about 30 miles west of Lancaster, can be reached by taking Avenue D west toward Gorman. In the old days, the Lancaster to Neenach road was called the Bailey Ranch Road, which eventually connected with the Ridge Route. Clarence Scates is shown with his brother Walter; they drove the stage between the two towns in 1912.

A lone car stirs up dust at the Ralph De Palma Racing Test Camp, which was located on Rogers Dry Lake from 1926 to 1933. The site was used to test racecars, and many speed records were set before it became a famous airbase (Muroc, which later became Edwards AFB). Drivers found its hard, flat surface ideal for racing, and Lancaster residents enjoyed coming here to see professional car races.

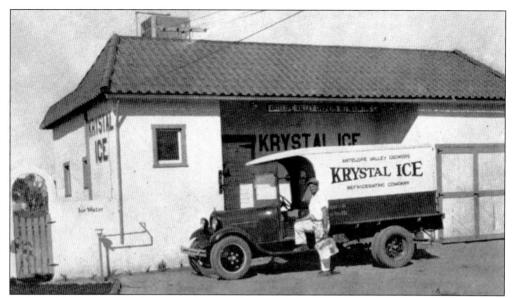

Having a sufficient amount of ice in the old days was very important. People would come into town and pick up ice at this plant, the "new" Krystal Ice distribution plant in Lancaster on Tenth Street near Fig Avenue, shown here in 1930. The main headquarters for this company was in Palmdale; it turned out three-and-a-half tons of ice every 24 hours.

In the early 1920s, affordable acreage, the growth of the alfalfa farms, and the proximity to Los Angeles led several entrepreneurial individuals to begin developing dairy herds in the AV. Although they wanted to promote the region as the "Milk Bottle of Los Angeles," they had to compete with existing dairies in Riverside. Several dairies in the valley became well known.

Horse buggies, racecars, and Model Ts have all been driven in Lancaster, but here is a rare "shoe vehicle," an Esperanza School float used during an Alfalfa Festival parade sometime in the 1930s. The theme for this float was the "Old Lady in the Shoe."

This 1950s Greyhound Bus depot on Beech provided Lancaster residents another way to commute to the Los Angeles basin. The bus depot is now located at the Metrolink train station, which is near the site of the old Lancaster Southern Pacific Railroad depot.

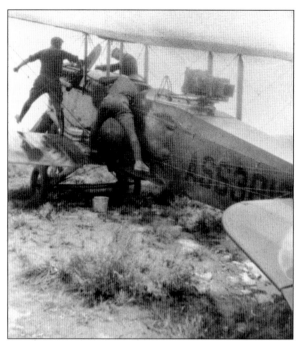

A silent movie outfit prepares to film in the vicinity of Avenue I and Fifth Street East c.. 1928. Note the camera attached to the plane. One of the most famous silent movies made here was Cecil B. DeMille's *The Ten Commandments*. filmed in June 1923 on Muroc dry lake. Lancaster merchants provided meals for the movie's crew, which included 500 people and 500 horses.

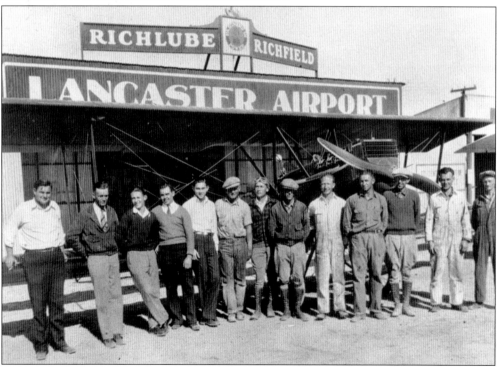

As early as 1918, planes were landing at Carter's Field, which would eventually become the Lancaster Airport. By 1925, Los Angeles County had plans to develop a portion of the area at present-day Tenth Street West and Avenue I, which had been donated by the B.F. Carter estate, into an airfield. The 80-acre airport officially opened in 1930 with two dirt regulation 1,500-foot runways. These local pilots pose with their planes at the airport's opening.

The old Carter Field/Lancaster Airport consisted of six planes and not much else. The little airport (at present-day Tenth Street West and Avenue I) was located at the town's outskirts; today the site is a shopping center.

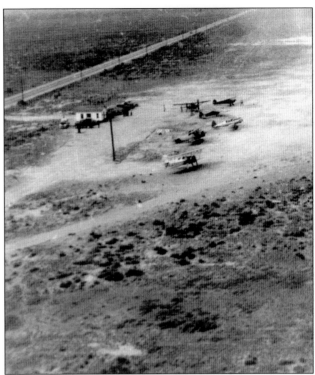

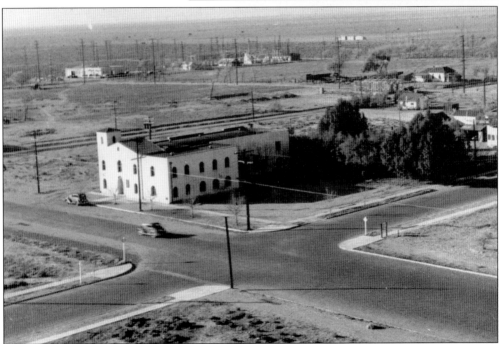

Here is a 1936 view of the Lancaster Airport and its three hangars (very top), the Southern California Edison electric company with its towers, which is now near Lancaster City Hall, and the Methodist church at old Tenth Street and Date Avenue. The photograph was taken from atop the water tower at the Los Angeles County Complex.

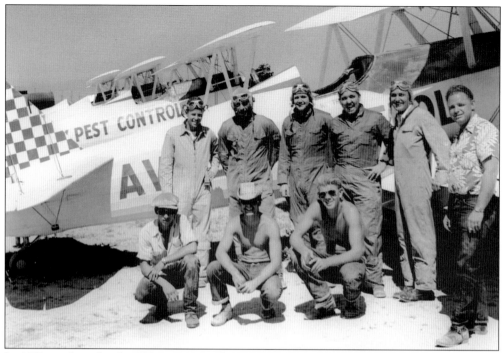

In 1952, workers for the AV Pest Control get ready to spray nasty pests, which could destroy local crops and farmers' livelihoods.

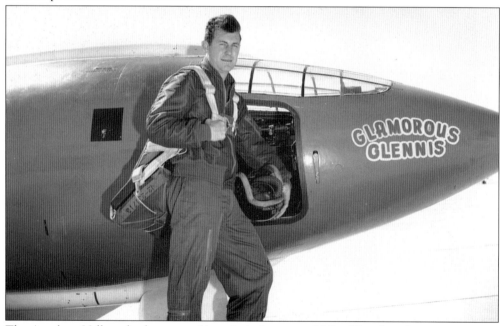

The Antelope Valley, also known as "America's Aerospace Valley," has long been synonymous with aeronautical achievements that have stirred our national pride and imagination. Charles "Chuck" Yeager was the first man to fly faster than the speed of sound on October 14, 1947, when he flew from Edwards AFB in his Bell X-1 aircraft, the "Glamorous Glennis." Many Lancaster residents worked at old Muroc Air Force Base, which was renamed Edwards AFB.

*Eight*

# FROM THE GOOD EARTH

Lancaster and the AV have been the site of many successful agricultural ventures. In the late 1880s and early 1890s, good conditions brought on by heavy rainfall attracted many land seekers and settlers and made for prosperous times. These early farmers and workers were photographed c. 1902.

Farming in the old days mainly involved cattle and sheep raising, fruit orchards watered by natural streams and creeks, and dry farming of grains like wheat and barley. Dry farming does not use irrigation but relies on rainfall provided by good old Mother Nature. Mr. Kellogg's gang plow with eight horses is hard at work. Not all early settlers were successful in their farming ventures.

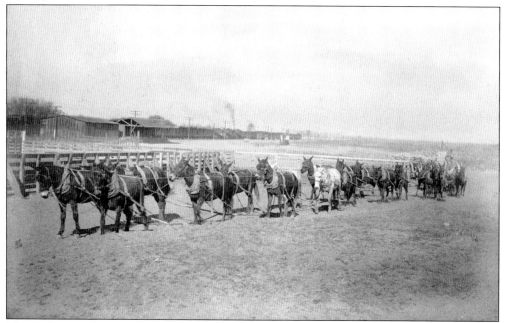

Many of Lancaster's first settlers arrived hoping to establish homesteads. The Homestead Act, which was passed by Congress in 1863, offered free public land in certain areas to settlers who would live on and improve tracts of land of up to 160 acres for five years. With only a $10 filing fee, virtually anyone could claim a quarter-section of public land—and there was lots of land around Lancaster.

The early 1890s were years of heavy rainfall and thus prosperous ones for farmers. Pipes were dug through the earth's crust to reach water, which would then shoot up under pressure. Land was also very cheap during this period. Here, E.E. Cummings (standing) shows prospective clients some choice land.

Water has been both a curse and blessing for the AV's inhabitants. This well was typical of those in the Lancaster area. The gasoline-powered pump was introduced to the valley in the early 1900s. Members of the Stuckey family and their dogs gather around a well, probably in the Rosamond area, c. 1902. Stuckey family members were frequent visitors to Lancaster.

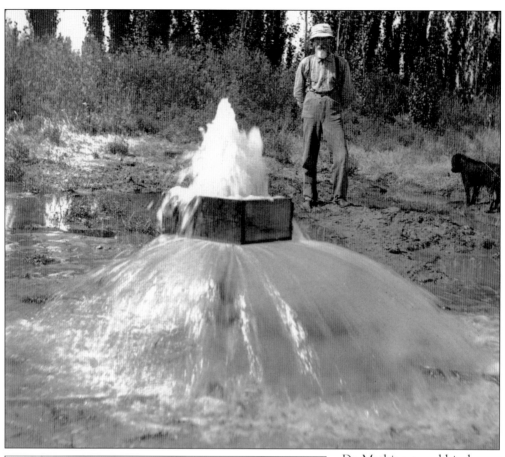

Dr. Mathiason and his dog stand by a flowing well around 1902. The first recorded artesian well in Lancaster was sunk around 1883. The first record of pumping water by engine power in the valley was in 1895. Mr. Noble made this experiment on his ranch about one-half mile south of town using a steam engine with straw as fuel to pump the water. The experiment was not successful.

Here is an example of an early well. Nearly every pioneer house had a water tank tower windmill.

By 1920, alfalfa was the principal crop in the valley, with 30,000 tons produced in 1921. During the 1930s, farming and alfalfa were the valley's major industries. In 1941 more than 100,000 tons of alfalfa was produced, of which 60–65 percent was used for dairy feed. Here, Helen Miller moves bales of hay at the Lancaster Fernando Mill during the 1940s. A woman's work is never done!

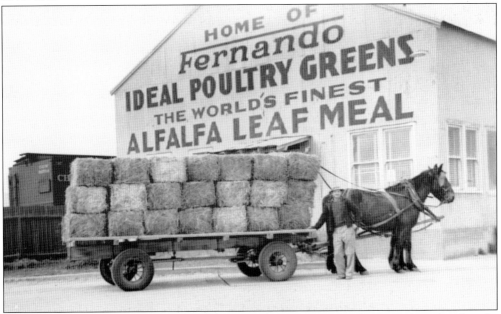

Built in 1933, Fernando Milling was an alfalfa meal mill. It was located next to the railroad tracks in Lancaster and sections of this business still exist. During the 1930s, Fernando Milling and Tropico Gold Mine were the largest employers in the valley. Many Lancasterites worked here.

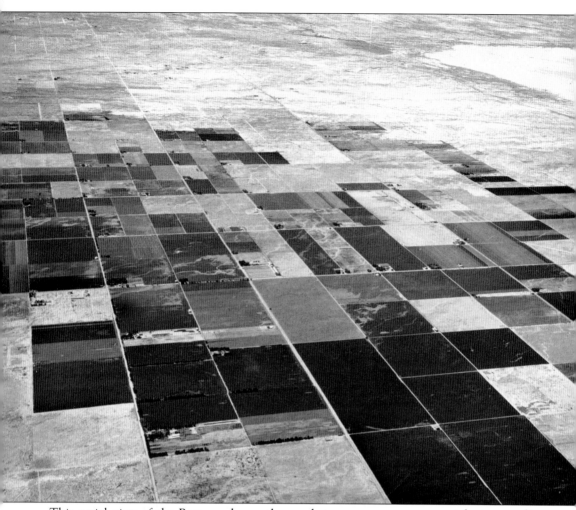

This aerial view of the Rosamond area shows what was once a common sight surrounding Lancaster: lush, irrigated fields. What a contrast with the surrounding barren desert floor. Note the dry lake in the upper right hand corner. Alfalfa became "king" of Lancaster agriculture in the 1920s, supported by irrigation from the well pumping of sub-surface water on the valley's floor. Agriculture was hurt by the Great Depression and a dropping water table in the 1930s. In the late 1940s and 1950s, alfalfa production boomed again as more efficient pumps coped with the dropping water table. The industry was hit hard by 1970s hikes in energy costs, and acreage decreased by the 1980s.

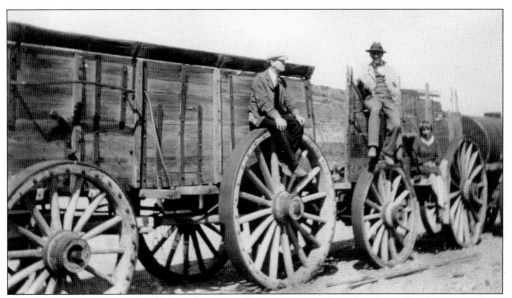

From 1884 to 1889, freight lines such as the famous Borax 20 Mule Teams hauled borax from Death Valley to Mojave. Mule power was the only means of direct freighting in the desert. Mojave blacksmith J.A. Delameter designed these big wagons. Some original wagons were still found in the Mojave area during the 1920s and were a popular tourist attraction with Lancaster residents. Here Halden family members climb aboard these wagons in Mojave.

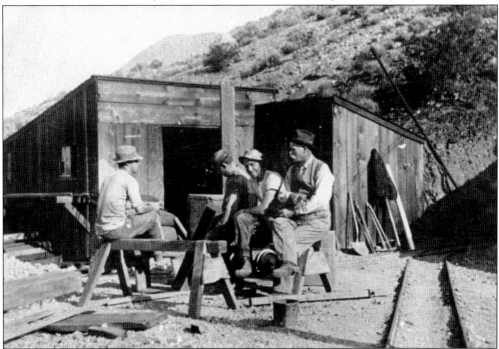

Mining was an important economic factor in the valley. This 1912 photo shows the entrance to Tropico Gold Mine in the Rosamond area, which employed many Lancasterites. After several early owners, the Burton Brothers took over the gold mining operations at this mine. During 1936 and 1937, as many as 200 men worked here.

As early as July 1892, William Mulholland was spotted in the Elizabeth Lake area planning his big water scheme, the Los Angeles Aqueduct (1907–1913), which drew water south from Owens Valley. This project "saved" Lancaster's and the AV's economy as many new jobs were created. According to 1910 census records, after English and Spanish, the most common language spoken by aqueduct workers such as these at the north end of the Elizabeth Lake Tunnel, was Russian/Serbian.

In 1901, prominent "Lancasterite" B.F. Carter began drilling for oil with two derricks, one drilled west of the Carter house on Antelope Avenue and the other about one-quarter mile east of the old fairgrounds, as shown in this photo. Supposedly Carter found oil but was unable to extract it. Carter spent more than $50,000 on these two unsuccessful oil wells. There were several later unsuccessful attempts by others to extract oil in the 1920s.

# *Nine*

# CHALLENGES

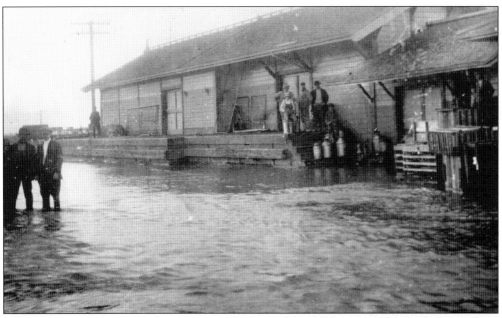

When it rains, it can certainly pour . . . and pour and pour. This scene shows the "great flood of 1914" that washed out the tracks at the Lancaster train depot. Several floods occurred in this area, especially during the 1910s, because of overflow problems in Amargosa Creek.

A destructive *c.* 1915 fire consumed the northwest corner of Tenth Street and Antelope Avenue and moved westward on Tenth Street. Early Lancaster fires wiped out many pioneer wooden buildings. Susie Oldham's well-organized "water bucket brigade" is credited with saving downtown Lancaster during one horrendous fire that scorched this same location during the spring of 1912.

Through the years Lancaster has been the site of several deadly train accidents and derailments similar to this one, which took place in 1917 near Vincent Hill in the Acton area and killed several people. These accidents could be caused by flooding, snow storms, or human error.

124

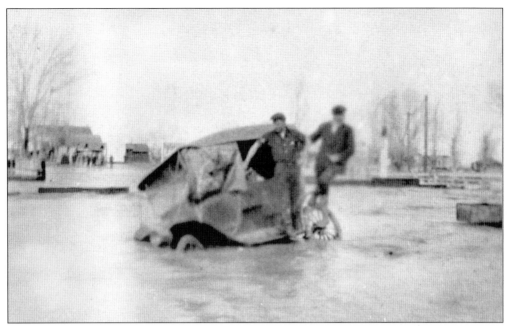

This car got stuck in the water near the Lancaster train depot during the flood of 1914. It was eventually removed with good old horsepower—the four-legged version.

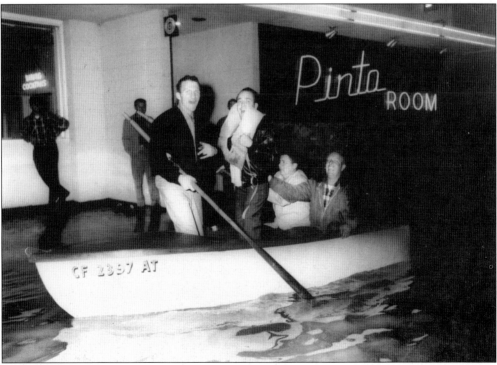

Although there was a section of Sierra Highway referred to as the "waterfront" (because of the number of bars located there), boats are still not a very common sight in downtown Lancaster. In 1965, however, after some horrendous rains, the Pinto Café on Yucca Street truly was a waterfront.

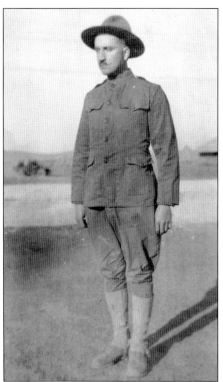

During World War I, 428 local men were registered for the draft. Eventually more than 250 of them served in the military—one-tenth of the population of the AV. Lancaster did its part and sent its young men, and fortunately only three valley men died during the war: one in action on his first day while another fell off a tower. The young soldier pictured here is a member of the Halden family.

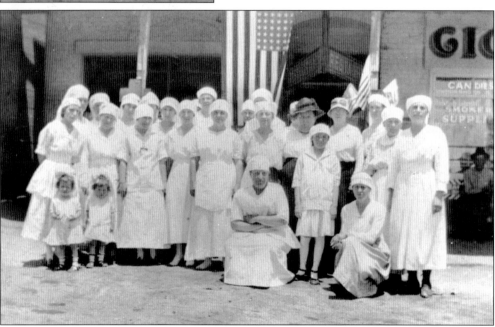

Local citizens did whatever they could to help the boys overseas during World War I, holding pie sales, hosting rabbit drives, and presenting balls at the Lancaster Women's Independence Club Hall. The selling of patriotic Liberty Bonds and special stamp programs also helped the cause. The Lancaster Red Cross and this one in Mojave sent "care packages" of socks, bandages, sweaters, and whatever else the soldiers needed.

In 1940, the British government needed help in training new pilots and contracted with several American flight schools. Because of the Antelope Valley's clear skies and open landscape, land was purchased at Sixtieth Street West and Avenue I. Polaris Academy was established at War Eagle Field. To ease the burden of being so far from home, the young English pilots were invited to local Lancaster homes for Sunday dinners.

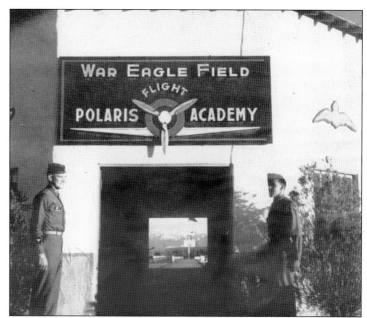

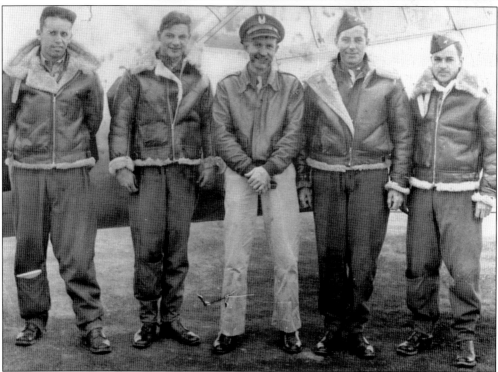

Royal Air Force cadets trained at Polaris Flight Academy from 1941 to 1943. As this program was being phased out, new training programs were needed to prepare American pilots for World War II. In 1943, Polaris Flight Academy became the Mira Loma Army Air Corps flying school. Harry Granger, center, was an instructor at the academy; his mother, Clema, was a pilot who flew with Amelia Earhart and Pancho Barnes in early powder puff races. Earhart visited Lancaster in the early 1930s.

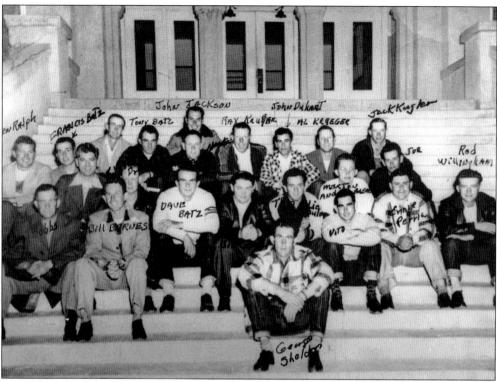

The photo includes the following handwritten names: Ben Ralph, Francis Batz, John Jackson, Tony Batz, John Dukart, Ray Krueger, Al Kreger, Jack Kugler, Dobbs, Bill Barnes, Dave Batz, Marlow Anderson, Vito, Joe, Rod Willingham, Vinnie Perrin, George Sheldon

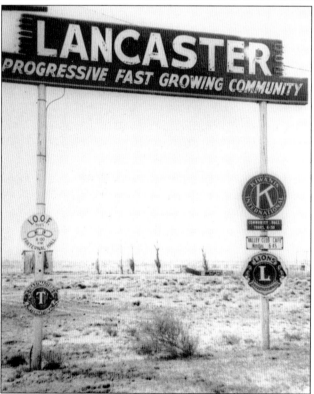

World War II meant the rationing of sugar, gasoline, and tires. There were also war bond drives. A significant portion of the valley's population was of German heritage, and the valley certainly felt the pressure of war and patriotic fervor. This 1946 photo shows recently returned veterans on the steps of the high school.

Lancaster was home to around 3,600 residents in 1950. With the advent of the jet age, Edwards AFB, and USAF Plant 42, Lancaster was ready for progress and rapid growth, as indicated by this billboard.